JOHN TWACHTMAN

CONNECTICUT LANDSCAPES

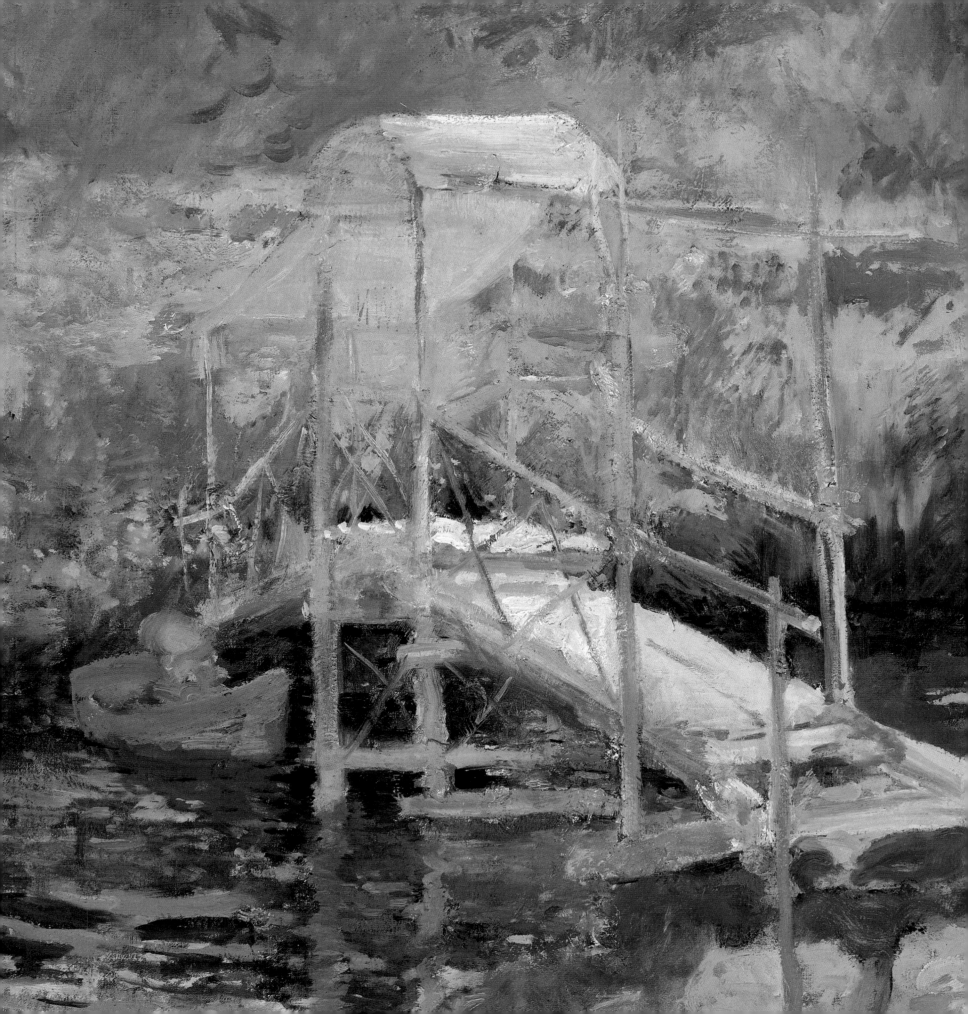

JOHN TWACHTMAN

CONNECTICUT LANDSCAPES

Deborah Chotner

Lisa N. Peters

Kathleen A. Pyne

National Gallery of Art, Washington

DISTRIBUTED BY HARRY N. ABRAMS, NEW YORK

The exhibition at the National Gallery of Art is supported by Bell Atlantic

JOHN TWACHTMAN
CONNECTICUT LANDSCAPES

National Gallery of Art, Washington
15 October 1989–28 January 1990

Wadsworth Atheneum, Hartford
18 March–20 May 1990

This book was produced by the editors office, National Gallery of Art.
Editor-in-Chief, Frances P. Smyth
Edited by Jane Sweeney
Designed by Chris Vogel
Typeset by BG Composition, Inc., Baltimore, in ITC Galliard
Printed by Schneidereith & Sons, Baltimore, on 80 lb. LOE Dull text

COVER: cat. 1. John Twachtman, *Winter Harmony* (detail), c. 1890–1900. National Gallery of Art, Washington, Gift of the Avalon Foundation

FRONTISPIECE: cat. 20. John Twachtman, *The White Bridge* (detail), c. 1900. Memorial Art Gallery of the University of Rochester, Gift of Emily Sibley Watson

BACK COVER: cat. 19. John Twachtman, *The White Bridge* (detail), after 1895. The Minneapolis Institute of Arts, The Martin B. Koon Memorial Collection

Dimensions are given in inches followed by centimeters in parentheses.

Library of Congress
Cataloging-in-Publication Data
Chotner, Deborah.
 John Twachtman : Connecticut landscapes / Deborah Chotner, Lisa N. Peters, Kathleen A. Pyne.
 120 p. 280 cm.
 Includes bibliographical references.
 ISBN 0-89468-137-0 (paper)
 ISBN 0-8109-1671-1 (cloth)
 1. Twachtman, John Henry, 1853–1902—Exhibitions. 2. Greenwich (Conn.) in art—Exhibition. I. Peters, Lisa N. II. Pyne, Kathleen A., 1949– . III. Title.
ND237.T85A4 1989
759.13—dc20 89-12771
 CIP

The clothbound edition distributed by
Harry N. Abrams, Inc., New York
A Times Mirror Company

CONTENTS

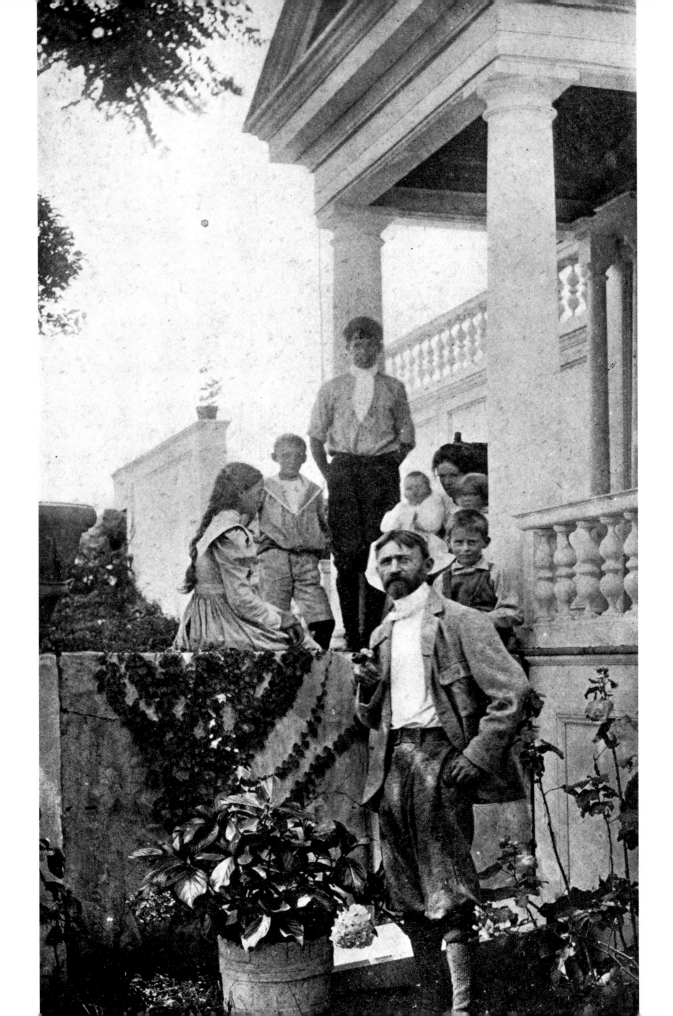

FOREWORD

John Twachtman: Connecticut Landscapes is the third and final part of a series of exhibitions featuring American impressionist artists. It, like *William Merritt Chase: Summers at Shinnecock 1891–1902* (1987) and *The Flag Paintings of Childe Hassam* (1988), examines a single, central aspect of an artist's career. The Twachtman project focuses on those paintings that relate to the painter's farm in Greenwich, Connecticut, or its immediate vicinity. The idea for these undertakings, first proposed by the curator of American art, Nicolai Cikovsky, Jr., came from the desire to carry out concentrated explorations of certain major objects in the collection of the National Gallery of Art. Although the scope of the project eventually expanded, the idea of tightly focused presentations was never abandoned. The results have been exhibitions invitingly intimate in scale, yet impressive in their intensity. For their generous and enthusiastic support we are grateful to Bell Atlantic, which has undertaken sponsorship of the entire series.

Many of Twachtman's paintings were purchased by museums early in this century and have become featured objects in their American paintings galleries. To these institutions, several of which have lent more than one work to this exhibition, we offer heartfelt collegial thanks. To all of the private collectors who parted with treasured objects we are similarly grateful. For the selection of pictures and for the organization of *John Twachtman: Connecticut Landscapes* we acknowledge the considerable efforts of Deborah Chotner, assistant curator of American art at the National Gallery.

We are delighted to have the opportunity to share this exhibition with the Wadsworth Atheneum. It is fitting that this extraordinary group of paintings should return to the lovely New England state that first inspired their creation.

J. Carter Brown
Director, National Gallery of Art

Gertrude Käsebier, *John H. Twachtman and His Family, Taken at His Home in Greenwich, Connecticut*

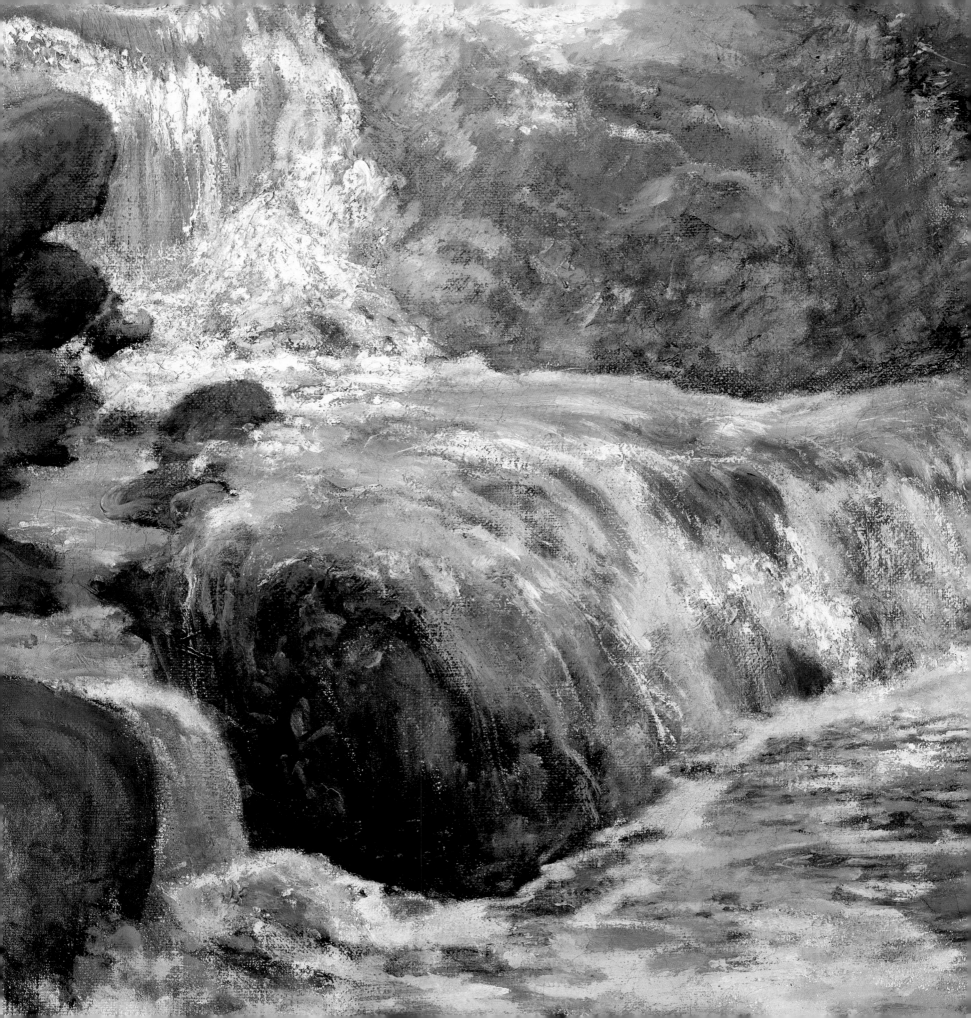

LENDERS TO THE EXHIBITION

The Addison Gallery of American Art, Phillips Academy, Andover, Massachusetts
The Art Institute of Chicago
The Carnegie Museum of Art, Pittsburgh
Cincinnati Art Museum
File Collection (Courtesy R. H. Love Galleries, Chicago)
Mr. and Mrs. Hugh Halff, Jr.
IBM Corporation, Armonk, New York
Mead Art Museum, Amherst College, Massachusetts
Memorial Art Gallery of the University of Rochester
The Minneapolis Institute of Arts
Museum of Fine Arts, Boston
National Gallery of Art, Washington
National Museum of American Art, Smithsonian Institution, Washington
The Phillips Collection, Washington
Mr. and Mrs. Meyer P. Potamkin
Private collection (Courtesy Graham Gallery, New York)
The Saint Louis Art Museum
Spanierman Gallery, New York
Mr. and Mrs. Ralph Spencer
David Warner Foundation, Tuscaloosa, Alabama
Wichita Art Museum

cat. 21. John Twachtman, *Waterfall, Blue Brook* (detail),
c. 1899. Cincinnati Art Museum, Annual Membership
Fund

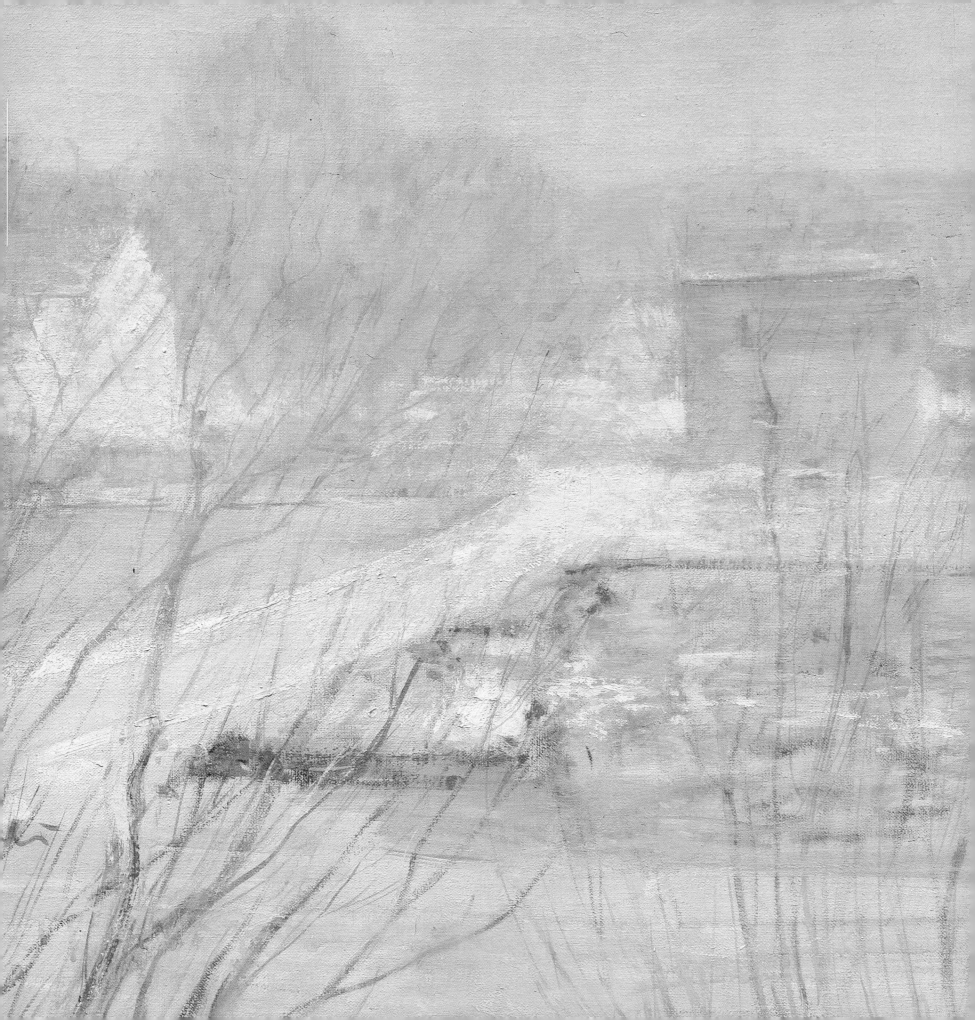

ACKNOWLEDGMENTS

This exhibition and catalogue are the result of the efforts of a great many people. Lisa N. Peters not only contributed a most informative catalogue essay but, in her capacity as co-author of the forthcoming John Henry Twachtman Catalogue Raisonné, shared her expertise concerning authenticity, dating, and location for many of Twachtman's paintings. She also responded generously to repeated inquiries concerning the artist's career and family. Kathleen A. Pyne authored an intriguing essay that is the first published exploration of the intellectual and psychological context for Twachtman's painting.

At the National Gallery, the exhibition catalogue was expertly edited and designed by Jane Sweeney and Chris Vogel, respectively. Barbara Bernard of the department of photographic services diligently collected the crucial photographic materials. As always, the Gallery's office of the registrar, and the departments of design, exhibitions, and conservation worked to the highest standards of professionalism and creativity.

Two members of the Gallery's American art department were especially helpful. Nicolai Cikovsky, Jr., curator of the department, advised on the selection of objects and on the direction of both exhibition and catalogue. Rosemary O'Reilly ably handled the multiplicity of lists, correspondence, and travel arrangements.

At the Wadsworth Atheneum we had the pleasure of working with Linda Ayres, associate director for exhibitions and public programs, and Elizabeth Mankin Kornhauser, research curator of American paintings, under the direction of Patrick McCaughey.

To these colleagues and to our generous friends, the lenders, we extend our sincere gratitude.

Deborah Chotner

cat. 25. John Twachtman, *From the Holley House* (detail), c. 1901. Mr. and Mrs. Hugh Halff, Jr.

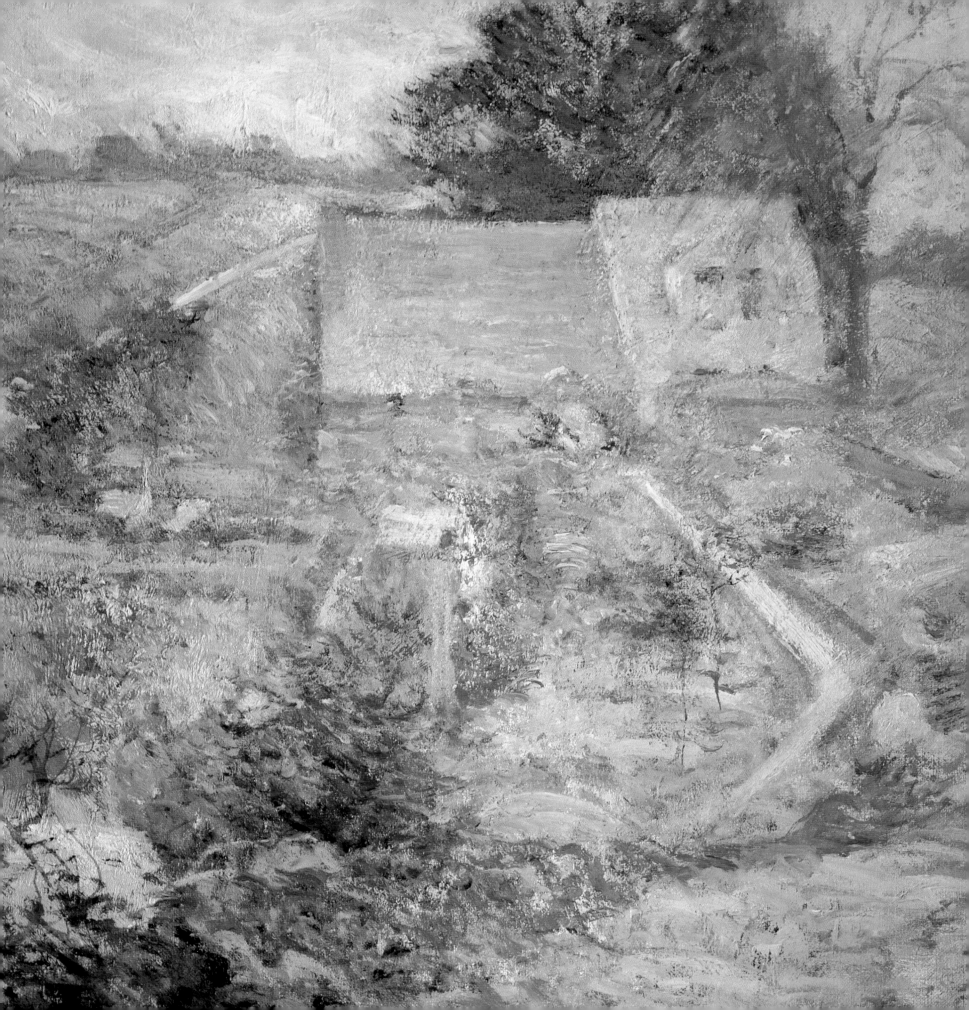

TWACHTMAN'S GREENWICH PAINTINGS: CONTEXT AND CHRONOLOGY

Lisa N. Peters

John Henry Twachtman created the majority of his finest works in Greenwich, Connecticut, at his home on Round Hill Road and on the seventeen acres of property he purchased in 1890–1891. His familiar surroundings provided him with a source of constant inspiration, and his paintings express his emotional responses to the landscape.

During his Greenwich period Twachtman reached his artistic maturity. His time in Connecticut was, however, preceded by years of training, foreign travel, and artistic productivity. The work he had created earlier provided an essential basis for the formation of his Greenwich aesthetic and vision.

The first phase of Twachtman's career began in 1875 when he left his native Cincinnati to accompany Frank Duveneck, his teacher and friend, to Munich.[1] Enrolling at the Royal Academy, Twachtman received instruction from Ludwig Loefftz, a painter of realistic genre scenes.[2] The study of Old Master techniques advocated by academy teachers and the bold experimental idiom in which Duveneck and other younger Munich men were painting influenced Twachtman. His forceful realist manner may be seen in the paintings he completed in Venice in 1877–1878, and in the harbor scenes he created in New York in 1878–1879 (fig. 1). In contrast to the detailed and highly finished landscape style that had been the hallmark of the Hudson River school painters, Twachtman rendered his scenes *alla prima* (all at once), applying heavy impasto directly on canvas with bravura brushwork. He also expressed his subjective responses to the landscape with dramatic contrasts of light and dark and the juxtaposition of solid masses and areas of open space. By the time he returned to the United States in the winter of 1878, Twachtman was recognized as one of the leading American proponents of the radical Munich style. Settling in New York, he became involved in the progressive art community, participating in the first exhibition of the Society of American

cat. 15. John Twachtman, *From the Upper Terrace* (detail), c. 1890–1900. File Collection, Courtesy R. H. Love Galleries, Inc., Chicago

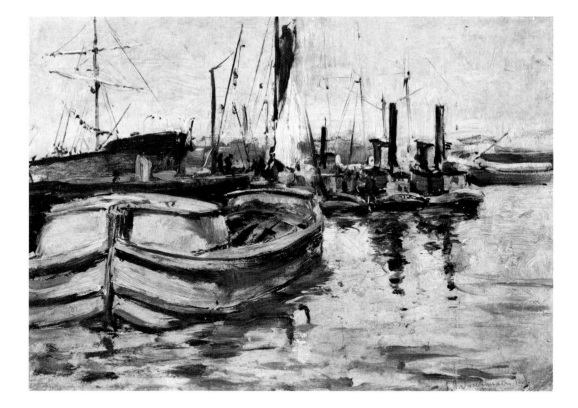

fig. 1. John Twachtman, *New York Harbor,* c. 1879. Cincinnati Art Museum, Bequest of Mr. and Mrs. Walter J. Wichgar

Artists in 1878, and joining the Tile Club where he formed important friendships with such artists as J. Alden Weir, R. Swain Gifford, and the architect Stanford White.[3]

By 1882, however, Twachtman felt that he had exhausted the possibilities of his Munich manner, and his second stylistic term began during his 1882–1883 stay in the Cincinnati suburb of Avondale.[4] In the works of his Avondale period, Twachtman lightened his palette, spread his paint more thinly, and organized his compositions more thoughtfully. He had been to Holland in 1881, and the works of the contemporary Hague school painters, which he could have seen, may have had an impact on the change in his work.[5]

Twachtman's third period was initiated in the fall of 1883 when he went to Paris, where he continued his studies at the Académie Julian under Gustave Boulanger and Jules-Joseph Lefebvre. He described his training in a letter to J. Alden Weir: "I am drawing from the figure, nude this winter and you know how much I need drawing."[6] However, during the summers he concentrated on depicting the landscape, painting in Normandy—Honfleur, Dieppe, and Arques-la-Bataille—and in Holland. His French-period style was the antithesis of his Munich style. He began to apply his paint in thin, unobtrusive strokes, resulting in smooth surfaces. He turned away from strong contrasts, creating softly lit scenes in which silver gray and light green dominate. The influence of the art of James McNeill Whistler is suggested in the gentle tonal arrangements of Twachtman's French-period canvases and in the quiet moods of

fig. 2. John Twachtman, *Arques-la-Bataille,* 1885. The Metropolitan Museum of Art, New York, Morris K. Jesup Fund, 1968

reverie they express. In comparison with the free and assertive technique used for his Munich paintings, Twachtman's French method demonstrates a new discipline and control. He tempered the naturalism of his scenes with a consciously imposed order, and a sense of abstract design emerges in many works from this period, especially in the famous *Arques-la-Bataille* (fig. 2).

Little is known of Twachtman's activity in the years immediately following his return to America in late December 1885 or early January 1886, and few works from this time can be identified.[7] He assisted on a cyclorama in Chicago in the winter of 1886–1887, although the nature of this project is not known today.[8] A landscape dated 1887 suggests that between his French and Greenwich periods he returned to his looser, more spontaneous Munich style (fig. 3). A group of works he created in Newport in the summer of 1889 indicates that he had struck a balance between the painterliness of the Munich idiom and the tighter approach of his French style (fig. 4). Twachtman's stay in Newport is confirmed by a number of entries in the diary of Anna Hunter, one of his students.[9] The artist took his charges outdoors to paint, and his 1889 summer class may have been one of the first plein-air art classes in America.[10]

Twachtman probably spent much of his time in New York between returning from Europe and taking up residence in Greenwich, as he gave his address as the Benedict building on Washington Square in several exhibition catalogues during the late 1880s.[11] It is likely that he moved to Greenwich in the fall of 1889, shortly after he had been as-

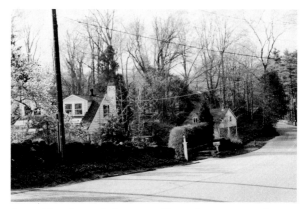

sured of a teaching position at the Art Students League in New York, and after he had received his share of the proceeds from the exhibition and sale of his work and that of Weir, which was conducted by Ortgies & Co. at the Fifth Avenue Galleries in New York in February of that year.[12]

Twachtman's discovery of his Greenwich property was described by John Douglass Hale:

> It was while he was in Newport with his students that a friend mentioned the landscape around Greenwich. He investigated, taking with him his son, J. Alden, who was then seven. They were about two miles outside of town, looking over a seventeen-acre farm through which flowed a stream known as Horseneck Brook. Suddenly the elder Twachtman threw up his arms in delight as he shouted, "This is it!" They had come upon the vigorous little cascade that the artist was to make famous with his paintings, Horseneck Falls. After that even the farm house, small and unattractive as it was, could not dampen his ardor.[13]

Although they are extremely varied in palette, brushwork, and composition, almost all of Twachtman's Greenwich canvases depict the same few subjects. He found constant renewal and delight in his home and his familiar landscape.[14] Today, despite vast changes in the vegetation, the property looks much as it did during Twachtman's lifetime. Though the barn was renovated recently and a dormer window added to it (fig. 5), the house has changed very little since the artist's death in 1902 (figs. 6, 7).[15]

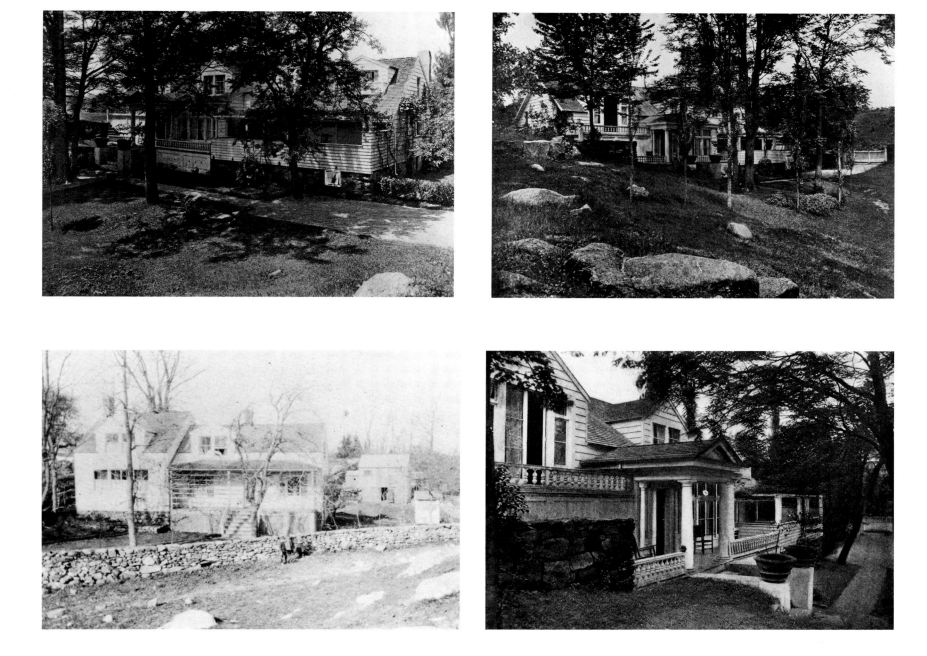

UPPER LEFT, UPPER RIGHT, LOWER RIGHT: figs. 6, 7, 9.
Twachtman's property on Round Hill Road, Greenwich,
c. 1902
LOWER LEFT: fig. 8. Twachtman's house and barn,
Greenwich, early 1890s

During his tenure in Greenwich, Twachtman remodeled his residence, turning it from a small farmhouse into an extended dormered structure. He adjusted each new addition to the rising slope of the land, merging the house with its site.[16] A photograph taken in the early 1890s shows it before many of the alterations were made (fig. 8). Sometime later the front porch was enlarged and covered with a trellis, and the east end of the building was extended. A classical portico designed by the architect Stanford White was erected in the mid-1890s (fig. 9).[17]

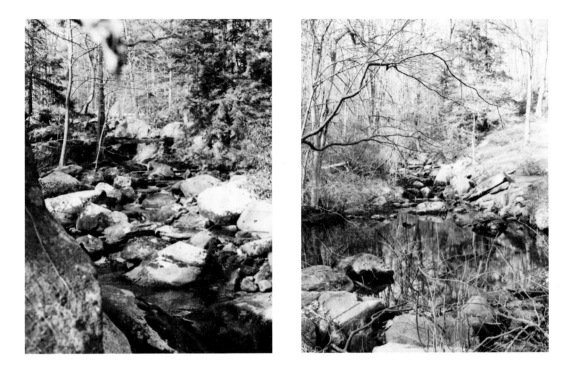

ABOVE LEFT: fig. 10. Waterfall on Horseneck Brook on Twachtman's Greenwich property, 1988

ABOVE RIGHT: fig. 11. Pool surrounded by hemlock trees on Twachtman's Greenwich property, 1988

cat. 5. John Twachtman, *Hemlock Pool* (detail), c. 1900. The Addison Gallery of American Art, Phillips Academy, Andover, Massachusetts

The property today reveals the same features that captivated the artist. Behind the house and at the bottom of a steep hill, the waterfall continues to pour over the rocky bed of Horseneck Brook, which is a full and forceful torrent during rainy seasons, a thin trickle in the dry spells of summer (fig. 10). Continuing further down the brook, one comes to the quiet pool surrounded by hemlock trees (fig. 11) that appears in *Winter Harmony* (cat. 1) and *Hemlock Pool* (cat. 5), two of Twachtman's best-known paintings. The white bridge that Twachtman constructed in the late 1890s stood below the pond over a section of the free-flowing brook.

A parallel can be observed between Twachtman's house and grounds and his paintings. In both, his innate sense of composition is evident. He accepted the terrain and enhanced it without attempting to change it, and similarly in his paintings he captured the sensuous beauty of scenes without exaggeration.[18] Through the gradual modifications made to his house and the cultivation of his property, Twachtman created an Arcadian setting in which wild nature was offset by civilized accents. Likewise in his paintings he achieved a balance between spontaneity and control.

Twachtman's adoption of impressionism naturally followed from his predilection for the everyday subjects and the intimate landscapes that he had painted throughout his career. Yet the impressionist style that he formulated was quite unique. He incorporated broken brushwork and a brilliantly colored palette only when these were required for expressive purposes. As a *New York Times* reporter noted, Twachtman "felt the influence of the students of sunlight and atmosphere; but he never gave himself up to the fascinations of 'decomposed colors' and 'vibratory' color effects as did some of his fellows."[19] His method consisted of applying paints with a loaded brush and

mixing them on the canvas. He also employed unusual procedures, such as exposing his paintings to sun and rain to relieve them of excess oil and to achieve the dry surfaces he preferred.[20] During his Greenwich period, it appears that Twachtman's general practice was to create his paintings outdoors, continuing the approach he had encouraged in Newport. However, he may have returned to a site many times before completing a work, and he also may have combined outdoor and indoor methods, completing works in his studio—reworking them while maintaining the freshness of his initial inspiration.[21] Twachtman probably rendered most of his paintings in many sittings rather than one, laboring over them to create unusual and beautiful effects through much underpainting and glazing. The impression of spontaneity was frequently achieved only by sustained effort.

Twachtman's natural ability in composition, "the great beauty of design" spoken of by Childe Hassam, is evident in his Greenwich imagery.[22] He was influenced by his formal training, as well as by Japanese prints, of which he was very fond, and possibly by Art Nouveau.[23] Despite the unplanned look of his pictures, Twachtman's conscious attention to his arrangements is evident in his overall patterned surfaces and his calculated placement of forms. He was especially aware of the relation between his motifs and the shapes of his canvases. He frequently used square canvases, making use of the format to express qualities of harmony and balance.[24]

Twachtman's life in Greenwich was more ordered than in previous phases of his career. He had married the amateur painter Martha Scudder in Cincinnati in 1881, and three children had been born before the move to Connecticut: John Alden (named after J. Alden Weir) in Cincinnati in 1882; Marjorie in Paris in 1884; and Elsie in 1886 after Twachtman returned to America. In Greenwich, the house on Round Hill Road provided a stable domestic environment in which the artist and his wife could raise their family. Four additional children were born in the 1890s: Eric Christian in 1891; Quentin in 1892; Violet in 1895; and Godfrey in 1897. However, the death of Eric Christian in 1891 and Elsie in 1895 reduced the number of his surviving children to five.

Twachtman maintained contact with his colleagues throughout his Greenwich years, visiting Weir in Branchville, Connecticut, and receiving guests at home.[25] Theodore Robinson was a frequent visitor both during the years when Robinson summered in France and after he settled in New York in 1892.[26] Childe Hassam often stopped by.[27] Robert Reid painted on Twachtman's property.[28] Twachtman also kept up his professional contacts in New York, meeting friends at the Players Club and viewing exhibitions of the Society of American Artists and the National Academy of Design in which he participated.

He grew closer to many of his colleagues as a member of the Ten American Painters, an organization of artists who exhibited as a group, most of whom painted in an impressionist style. The Ten included Twachtman's friends Weir, Hassam, Reid, Thomas Dewing, and other New York and Boston artists. Twachtman was involved in the organization from its inception in 1897. He contributed paintings to its exhibitions throughout the remainder of his life, and his work was included in two shows following his death.

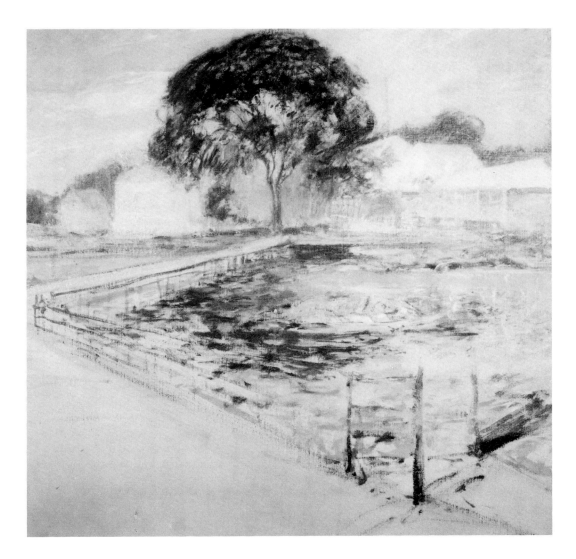

fig. 12. John Twachtman, *Harbor View Hotel*, c. 1902. Nelson-Atkins Museum of Art, Kansas City, Missouri

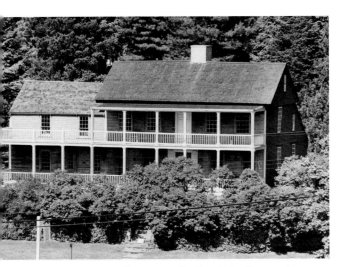

fig. 13. Bush-Holley House in Cos Cob, Connecticut, museum and headquarters of the Historical Society of the Town of Greenwich

Twachtman was also reunited with a number of his old friends during the summers of 1900 to 1902 when he stayed in Gloucester, Massachusetts.[29] These summers, which brought together many of the circle of artists who had gathered around Frank Duveneck in Munich and Italy during the late 1870s and early 1880s, were among Twachtman's most social. They also produced paintings of harbors and of the coastal town that revealed the vibrant and powerful new direction that characterized Twacht-man's last stylistic phase. In the works created in Gloucester, the artist painted *alla prima,* returning to the vigorous painterly style of his Munich years while retaining the bright colors of his Greenwich canvases (fig. 12).

During the 1890s and the early years of the twentieth century, Twachtman visited Cos Cob, a fishing community that was part of Greenwich, where he stayed at the Holley House (fig. 13). He had begun teaching in Cos Cob by 1892, and by 1899 he was attracting large groups of students to the harbor site.[30] Many of his most striking late

works were rendered from the upper and lower porches of this house, looking out over a bridge that crossed the Mianus River, a view now largely obscured by a freeway overpass. Gatherings at the Holley House often brought together groups of artists and writers, and the autobiography of Lincoln Steffens includes recollections of Twachtman's participation in house events.[31]

Life was not easy for Twachtman during the Greenwich years. Scarlet fever swept through the family in 1895, resulting in the death of his daughter Elsie.[32] The artist himself was ill at times during the period.[33] He also faced constant financial straits, as very few of his works sold.[34] Weir wrote that Twachtman had indeed been demoralized by the lack of public appreciation of his art.[35] Considered a "painter's painter," Twachtman was held in higher esteem by artists than by lay audiences.

When he died in Gloucester in August 1902, a few days after his forty-ninth birthday, Twachtman was creating some of his best canvases. The Gloucester paintings demonstrated a new forcefulness and modernity that forecast his continued artistic prominence. His colleagues predicted the stature that his work would one day attain. Weir, for example, wrote that Twachtman "had been in advance of his age,"[36] and Dewing that he was "too modern, probably, to be fully recognized or appreciated at present; but his place will be recognized in the future."[37]

In the course of his career, Twachtman explored different aesthetic issues. Yet the evolution of the works within each of his stylistic phases cannot be so easily tracked. This is especially true of his Greenwich period, which lasted the longest and in which the artist was the most prolific.

The chronology of his Greenwich works is extremely difficult to construct. Although he had dated some of his canvases in the 1870s and early 1880s, he abandoned the practice in Connecticut. With the exception of a few letters, there is little archival material, documentary or photographic, to assist in a consecutive ordering of his oeuvre. Published records do not provide a thorough or consistent source either, although in some cases the identity of a painting or pastel may be determined through a description in an exhibition review. In the exhibitions in which he participated Twachtman used titles repeatedly for different canvases and often changed their names from one show to another. *The Brook, Brook in Winter, Hemlock Pool,* and *The Waterfall,* listed in exhibition catalogues in the 1890s, could refer to any number of works.

The Greenwich paintings themselves reveal few clues about their histories. Twachtman made many changes to his property and to his home on Round Hill Road, yet his images do not provide a reliable record of them. It is clear that *Summer* (cat. 16), a depiction of Twachtman's house from the back, was painted later than other renderings of the same view such as *Snowbound* (fig. 14) or *From the Upper Terrace* (cat. 15), because in *Summer* a second dormer window appears on the roof that is not evident in other works. For the most part, however, determinations based on the appearance of motifs are misleading, for Twachtman took liberties in rendering his subjects. The locations are the same from one work to another, and it was mainly the artist's changing

fig. 14. John Twachtman, *Snowbound,* early 1890s. Montclair Art Museum, Montclair, New Jersey, Museum Purchase, Lang Acquisition Fund, 1951

feelings for them, conveyed through expressive means, that were responsible for their variations.

Even stylistic analysis can be deceptive. Many of the same formal concerns such as an interest in atmosphere, a consciousness of design, and a tendency toward abstraction preoccupied Twachtman throughout the Greenwich period. He adjusted his artistic means to convey his feelings for his subjects, painting the different seasons with sensitivity to their unique qualities. His choice of an approach was to a large extent dictated by his emotional response rather than by a new method or aesthetic.

For this investigation of the chronology of Twachtman's Greenwich paintings, the period will be considered in three phases, each related to a major exhibition of the artist's work. In each he shifted his stylistic vocabulary and technical methods in order to express his changing artistic viewpoint. Contemporary newspaper and magazine reviews and other available documentary material, in combination with a study of the works, reveal a sense of the artist's development during the period.

The first phase culminated with Twachtman's one-man show in March 1891 at the Wunderlich Gallery in New York, which included thirty pastels and twelve oil paintings. One pastel titled *On Wier's Farm* [sic] proves that at least some of the work shown at Wunderlich had been executed in Branchville, Connecticut, probably in the late 1880s when Twachtman had spent time near Weir's property.[38] Several titles denote

Greenwich locations, however, such as the painting *Hemlock Pool,* and pastels *Horse Neck Brook, Road to Round Hill, Horse Neck Bridge,* and *House at Hang Root,* [39] and it seems certain that the Wunderlich exhibition was the first to include Greenwich works. [40]

The largest portion of the show was given over to pastels. During the previous few years of the artist's career he had explored the medium extensively. His interest was undoubtedly spurred by his involvement in the Society of Painters in Pastel, an organization initiated in 1884 and to which a number of his close colleagues belonged, including Robert Blum, William Merritt Chase, and Theodore Robinson. [41] Although he had not participated in the first exhibition in 1884 (he was in Europe at the time, and may not yet have begun to create pastels), he submitted a large number of works to the three subsequent shows that the society held in 1888, 1889, and 1890.

The critics commented on Twachtman's pastel technique in their reviews of the society's exhibitions. Of his 1890 showing, the *New York Times* reported that "He uses paper of different shades—brownish, greenish, grayish, or pale straw, and does not elaborate and insist too much on his picture. He leaves the paper ground a good deal bare, and sketches, rather than draws, an elaborate picture." [42] The same lightness of touch and economy of means were also noted of the pastels he displayed the next year at the Wunderlich Gallery. [43]

A comparison between Twachtman's works and those of Whistler was a focus of reviewers' columns in 1891, especially in the case of the pastel styles of the two artists. One wrote that "Like Whistler [Twachtman] uses for pastels often a brown, rough paper and makes the tone of the paper tell." [44] Another wrote that "Upon a background of slate-colored lawn the artist has arranged . . . forty-four illustrations, the majority of which are mere suggestions and delicate color effects. The whole display 'out Whistlers Whistler.' " [45]

The connection between the two artists was probably reinforced by the similar presentations of Twachtman's Wunderlich exhibition and one of Whistler's work that had been held in 1889, also at Wunderlich. [46] For both shows, the gallery was decorated to enhance the pictures presented. The *New York Sun* reported of the Whistler exhibition that "Of course, the exhibition is as Whistlerish in its setting as in the essence of the work it shows. The room is pink throughout." [47] Twachtman's show was described in similar terms. The *Studio* reported that "All the surroundings are in harmony with the delicate tints of the paintings; even the chairs are painted some light color, and grayish hangings on the walls serve as an excellent background to the white and daintily framed pictures." [48] The reviewer for the *New York Evening Post* also commented on the rapport between the works and the environment, writing that "It is only by looking intently at the walls for a moment that one perceives that there is no dust, but that the impressing of its existence is given by the peculiar effect of white cheesecloth stretched on the walls, the pale ashiness of tone of most of the pictures and the white frames in which they are bordered." [49]

Pastels dominated Twachtman's 1891 Wunderlich show and thus may have had the greatest impact on viewers. More of the criticism was, in fact, directed at the pastels

than at the twelve oil paintings. One critic compared the examples in the two media, stating that "The pictures in oil are characterized, most of them, by more vigor and reality, but strength is not a prime quality in Mr. Twachtman's work."[50] Other reviewers included the paintings along with their general appraisals of the show. One described the pictures in both media as "Very dainty, very light in tones."[51] Another noted a uniformity among the selections, calling them "'harmonies' of green and gray and pale gold."[52] Twachtman's pastel technique had a significant effect on his method of oil painting that lasted throughout his career; from it he undoubtedly gained spontaneity and an awareness of color. In addition, he learned from pastels the value of using lighter, brighter pigments over darker, duller ground.[53] During his early Greenwich years, the impact of the pastel work on the oils may have been particularly pronounced: it seems quite likely that the soft tonal values and delicate atmospheric effects of his oil paintings were inspired by the aesthetic of his pastels.

These qualities were recognized especially in Twachtman's snow scenes, which accounted for more than half of the canvases in the 1891 exhibition. A critic for the *New York Evening Post* commented that "In the pictures of winter scenes, effects of snow in sunlight and under gray skies, we find the artist apparently at his best."[54]

In their discussions of Twachtman's winter scenes as well as of his other works, reviewers commended his ability to faithfully record nature without sacrificing its poetry. In this aspect of their criticism, a divergence may be seen in their evaluations of Twachtman and of Whistler. Although they had suggested an affiliation between the two artists' technical methods, they discussed their imagery in very different terms. In an article about Whistler's 1889 show, a *New-York Daily Tribune* reviewer commented: "He cares nothing for the exact facts which are before him, but his only purpose is to compose a little melody by selecting, arranging, and even modifying certain phases."[55] In their discussions of Twachtman's work, critics focused on the realism of his portrayal of outdoor scenes. A writer in the *Art Amateur* maintained that the artist had "successfully caught the spirit of the American landscape."[56] Others noted a lack of detail in Twachtman's works, yet felt the artist was an accurate observer of nature. The *Studio* asserted that

> No one could paint the whole so well as Mr. Twachtman paints it, who could not paint the parts with equal certainty, but somehow we should not expect to find the artist's portfolios full of anatomical studies of trees and leaves, cloud forms and rock formations. Yet there is science enough for the scientific: trees really growing; firmly planted, freely branching; here is the solid earth, and the runnel sauntering, according to the laws of gravity, through the snow-bound meadow; the brook leaping, foaming from rock to rock. . . .[57]

Most of the critics concurred that Twachtman's realism was not obvious. The *New York Times* reported that "Sometimes his method leaves us in doubt whether it is shaded snow he is painting or water, but his pictures grow on one with examination and their features become more distinct."[58] Another suggested that Twachtman's paintings had the capacity of luring one into the natural setting: "Here the painter leads you to some quiet spot—you see the damp melting snow,—the bare wet trees, and the swiftly flowing brook, you feel that the air is laden with moisture—it is one of

fig. 15. John Twachtman, *Winter Harmony*, c. early 1890s. Spanierman Gallery, New York

those gray, damp days. You are not restricted to the narrow limits of the canvas, you feel as though you could follow the brook's course farther down, and see way into the distance."[59]

Of the winter scenes exhibited, *The Barn-Winter* may have been similar to *Winter* (cat. 12) or *Winter Harmony* (fig. 15), both of which include images of the barn on Twachtman's property. A mention of the work presented at Wunderlich appeared in the *New York Evening Post:* " 'The Barn Winter' . . . with the pale sunshine falling on the white walls of the barn and the broad expanse of snow that covers the ground is truthfully observed, and the motive is interpreted with a great deal of refinement and distinction in the color scheme."[60] Two paintings that depicted the barn were included in the Wunderlich show, and the *Art Amateur* noted:

> "Snow in Sunlight" and "The Barn-Winter," were among the best. The scene is the same in both—a rocky bit of ground on the confines of a small wood, with a yellow barn in the middle distance. Nothing could be more prosaic as to its association, yet the painter has obtained from it two studies, which may be compared for poetic feeling to Whittier's "Snow-Bound." The changes of the shadows on the snow make them two different pictures.[61]

Winter, painted with soft pastel tonalities and subtle shifts of color to portray effects of light and shadow on snow, is quite possibly one of the works Twachtman exhibited at Wunderlich. The small barn appears isolated and distant, although it was actually only a hundred feet from Twachtman's house (see figs. 5, 8). The painting suggests the insignificance of human presence in relation to the expansive breadth of nature.

A similar feeling is conveyed in some of his depictions of the pool and surrounding

hemlock trees on his Greenwich property. The one painting of this subject included in the Wunderlich show was described as "a little valley or dale with bare trees growing on the sloping banks of a brook flowing down towards the front of the picture . . . a charming piece of painting, delicate and tender in color and simple in method."[62] Two depictions of the pool that may date from the first Greenwich phase are *Icebound* (cat. 2) and the National Gallery's *Winter Harmony* (cat. 1), both of which present the pool from the same oblique angle and convey a mood of hushed silence. *Icebound* expresses the quiet peacefulness of deep winter with a thick and heavy impasto, the iced-over blue patches of the pool creating sinuous patterns against the enveloping white blanket of snow. Twachtman accentuated the stillness of the scene by arresting our gaze in the middle ground and leading us slowly at a diagonal into the distance. *Winter Harmony* presents a more fragile and meditative view of the subject, drawing the observer into the silvery depths of the pool, the chilly air, the light snow cover, and the glistening, flickering leaves. The canvas exhibited in 1891 struck a similar chord in a contemporary critic: "the exquisiteness with which its values are rendered would alone make it a great landscape painting, but there is added to it that indescribable something which is the spirit of woodland winter."[63] The Washington *Winter Harmony* may be that painting.

By 1893, Twachtman's art was viewed more in relation to that of the French impressionists than to Whistler's. He was included in a joint exhibition with J. Alden Weir at the American Art Galleries in New York in May of that year. An exhibition of works by the French artists Claude Monet and Paul-Albert Besnard was held concurrently at the same place. The four artists were represented by different media and varying numbers of works: Monet and Besnard showed only paintings, fifteen by the former, and thirteen by the latter; Weir displayed twenty-one paintings and sixty-eight etchings, and Twachtman, twenty-eight paintings and sixteen pastels.[64] The two exhibitions were meant to be seen in conjunction with each other, allowing viewers to compare the two French and the two American artists whose art exemplified the most modern stylistic approaches of the day. The *New York Times* described it as "a large collection of paintings and pastels by four artists . . . who are devotees of the latest effort to give the impression either of sunlight in the open, or of the brightest diffused light when the sun is obscured."[65] The *New York Sun* announced: "Here is a treat for the apostles of light and air and the hot vibrations of sunlight in painting; for the devotees of simple abstract color and illumination. It is also a fine opportunity to compare the works of Monet, the most conspicuous of Parisian impressionists, with those of two of our own most advanced followers in his footsteps."[66]

Many of Twachtman's and Weir's critics found their works less radical than those of their French counterparts. One wrote, "While, like Monet, [Weir and Twachtman] have striven toward the expression of Impressions of landscape and figure, they have looked with soberer eyes. There is none of the splendid, barbaric color that distinguishes the works of the Frenchman. They tend to silvery grays modified by greens

and blues quite as silvery."[67] In general, reviewers found the canvases by Weir and Twachtman to be less intense in palette, and more concerned with tonal values than those of the French artists. Alfred Trumble wrote in the *Collector* that "When you turn around among the Weir and Twachtman pictures, you seem to be looking at Monet, at Sisley, at Bastien Lepage, through a fog, which washes out the force and substance and leaves the shadow. The mannerisms are all here. But the virile power is not."[68]

By the time of the 1893 exhibition, Twachtman would have had ample opportunity to become familiar with French impressionism. It is generally assumed that Theodore Robinson, who returned in 1892 from France where he had been in close contact with Monet at Giverny, played a more instrumental role in Twachtman's adoption of the style than did Twachtman's own direct contact with the French impressionists and their work. However, even if Twachtman had not seen French impressionist painting in Europe in the 1880s, he would have been aware of it in New York on his return to America. Twachtman may have seen the large exhibition held in April 1886 at the Durand-Ruel Galleries in New York, and works by the impressionists that were shown again at the same location in 1887.[69] It also seems unlikely that he would have missed the large Monet show at the New York Union League Club in 1891.[70] Yet as the perceptive critic Mariana G. van Rensselaer pointed out in her review of the 1893 exhibition, Twachtman and Weir "are both sincere and able painters, and they had both experimented for themselves before Monet's canvases became popular."[71] For Twachtman, exposure to impressionism did not prompt a new expression or a fundamental change in his attitude, but it did provide a means for conveying his immediate impressions of nature, which had been his primary concern since at least the beginning of the Greenwich period, if not from the start of his career. The success he had attained in reaching this aim was recognized by the *New York Sun* critic who pointed out that "Mr. J. H. Twachtman may be said to have come nearer than any New York artist to solving some of the problems of *plein aire* that Monet has set down."[72]

In a reversal of the critical reception of Twachtman's 1891 show, reviewers of the 1893 exhibition paid less attention to his pastels than to his oil paintings. Van Rensselaer recorded how Twachtman's pastels were perceived in 1893: "The poorest of Mr. Twachtman's works are the many pastels which hang in one of the small rooms. I cannot think that these are pictures in the true sense of the word. They are faint, vague, pretty harmonies of color, but they actually represent nothing and they even suggest half remembered dreams rather than actualities."[73] Her negative response to them may merely suggest her personal dislike of the drawings, but it is more likely that Twachtman's pastels lost their impact when seen in relation to the vibrant paintings in the exhibition—his own, as well as those of Weir, Monet, and Besnard. From Van Rensselaer's commentary it may also be inferred that Twachtman's oil paintings were less stylistically consonant with his pastels than they had been in 1891. The oil paintings that are known to have been included reveal that the artist had indeed begun to use stronger color contrasts and to render forms with more solidity.

Some of Twachtman's paintings shown in 1893 can be identified today. Among them are *In the Sunlight* (fig. 16) and *Mother and Child* (fig. 17).[74] Only one landscape

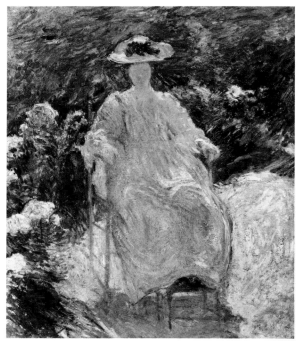

fig. 16. John Twachtman, *In the Sunlight,* c. 1893. Private collection

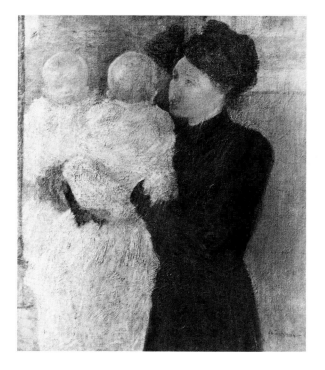

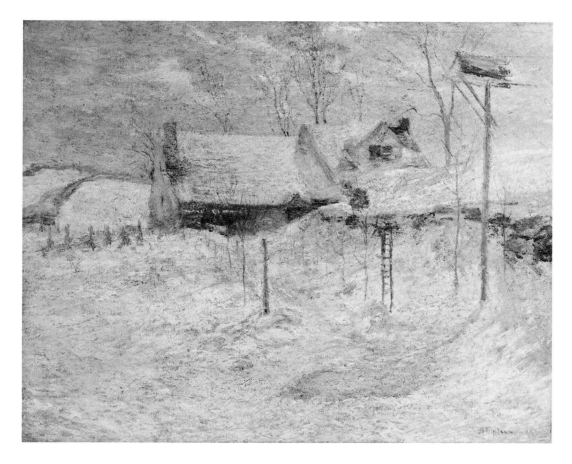

ABOVE: fig. 17. John Twachtman, *Mother and Child,* c. 1893. Fine Arts Museums of San Francisco, Jacob Stern Family Loan Collection

ABOVE RIGHT: fig. 18. John Twachtman, *Last Touch of Sun,* c. 1893. Manoogian Collection

exhibited in 1893, identifiable by its provenance, is currently known. This work, *Last Touch of Sun* (fig. 18), was included in the second annual exhibition of the Carnegie Institute, Pittsburgh, in 1897 and in the sixty-seventh annual at the Pennsylvania Academy of the Fine Arts, Philadelphia, in 1898, eventually entering the collection of Andrew Carnegie.[75] The artist showed several paintings of his residence in 1893. The *Art Amateur* observed:

> One of Monet's pictures is of his house in a garden of sunflowers; two are of haystacks; and Mr. Twachtman seems to have taken a hint of this preference for commonplace subjects made beautiful by light, and has given us several views of his house (more picturesquely situated, it is true) in summer and in winter. His snow scenes, with blue shadows are the most charming things he has done.[76]

Of the works shown in 1893, *My House and My Garden* (no. 17) was undoubtedly a summer view of the subject. *Snowbound* (no. 24) is likely to have been a depiction of the same motif in winter, and could be either of the paintings with this title that are known today, one in the Montclair Art Museum, New Jersey (fig. 14), and the other belonging to Scripps College (fig. 19). It seems likely that Twachtman had begun to depict the view of the back of his house shown in these works by or in early 1892, as Theodore Robinson, during a short visit with Twachtman, painted his own rendition of it in a work dated 17 January 1892 (fig. 20). Many of Twachtman's pictures of his

house were painted from a vantage point similar to that used by Robinson, as can be seen in a comparison of Twachtman's *Last Touch of Sun* and Robinson's *Twachtman's House.* However, Twachtman's composition appears more calculated than Robinson's as he contrasted the diagonal line of the stone wall at the right side of the canvas with the solid rectangle of the house in the center of the picture. Robinson's more simplified and frontal arrangement may have resulted from the fact that he rendered it outdoors. Robinson wrote, "It was painted quickly, as I was obliged to hurry—the day being a very cold one, only a little while the 2d day and an hour the first. I should work more in that way."[77]

Twachtman favored winter for a number of the works created during his second Greenwich phase, just as he did in the first phase. However, in relation to the total number of paintings shown in 1893, there were fewer snow scenes than in the 1891 exhibition.

Two other paintings listed in the 1893 exhibition catalogue can possibly be linked with extant works. *The Frozen Brook* (no. 2) and *End of Winter* (no. 9) may be the paintings of these titles known today (cats. 7, 8). The two depictions are similar, both featuring the brook curving through Twachtman's Greenwich property. *End of Winter* gives evidence of the influence of his pastel approach in the dry, sketchy application of paint over a light brown primed surface and in the fresh color, which conveys the crispness of the air. Touches of white impasto highlight patches of snow and ice, while thin washes of paint convey the soft and fragile qualities of the landscape.

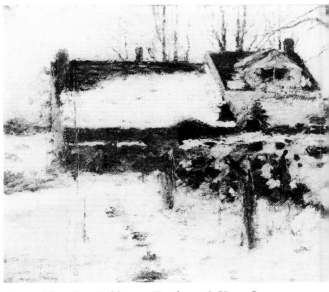

fig. 20. Theodore Robinson, *Twachtman's House.* Location unknown

Twachtman's 1893 exhibition appears to have included works in a broad range of styles. *In the Sunlight* and *Tiger Lilies* (Collection of Mr. and Mrs. Meyer P. Potamkin), which was probably the work of this title shown, reveal strong color contrasts and a vigorous and varied method of paint application. A critic commented that "Here . . . are two painters [Twachtman and Weir] who have been favorably known and appreciated for years as artists of positive and strongly original temperaments, what we should call distinctly artistic painters, who have within about three years changed their style radically. . . ."[78] In his journal on 24 December 1892, Robinson also noted that Twachtman had "done some good things—less foggy than usual."[79] Other works in the 1893 show such as *Last Touch of Sun* further demonstrate Twachtman's innovative method of building up the surfaces of his canvases by overlaying thick layers of paint, in this instance to convey effects of bright daylight on snow. Yet paintings such as *The Frozen Brook* and *End of Winter* would have indeed appeared pale and delicate in comparison with Monet's brilliantly colored paintings of haystacks and poplars. Despite a more dynamic and diverse approach and a higher-key palette, Twachtman's style was still poetic and refined when considered next to that of the French impressionists. His works were also seen as more decorative than Monet's, and the critics implied that whereas Monet was more concerned with truth than artistry, Twachtman gave precedence to aesthetic considerations over direct observation.[80]

After the 1893 exhibition Twachtman adopted a more experimental approach. When his painting *Autumn* won the Temple Gold Medal at the sixty-fourth annual exhibition of the Pennsylvania Academy of the Fine Arts in December 1894, a critic described it as "a small Impressionist picture—a misty agglomeration of blues and reds—a thing of shreds and patches."[81] *Hemlock Pool (Autumn)* (cat. 4) certainly matches this description, although there is no proof that it is the picture that Twachtman showed. When one compares this view of the hemlock pool with *Winter Harmony*, the artist's deemphasis of structural underpinnings, progression into space, and distinction between forms in *Hemlock Pool* become evident. However, when we view the work from a distance, the elements within the scene—the pool at center, and the hilly landscape around it—become readily distinguishable. The picture demonstrates Twachtman's interest in capturing an impressionistic glimpse of nature, rendering its fleeting, transient qualities. There is also a new attention to surface pattern; Twachtman delighted in rendering pure effects of light, color, and movement. A similar attention to decorative surface may be seen in *The Brook, Greenwich, Connecticut* (cat. 10), in which the broad slope of the landscape and the large looping curve of the brook are treated abstractly, and progression into the distance is denied by the flattening of the picture plane.

The two commissions that Twachtman received in the three years after his 1893 show allowed him to experiment to an even greater degree than before. The first was for a number of paintings of Niagara Falls ordered by Charles Cary, a Buffalo physician.[82] All of Twachtman's known Niagara images present the subject in winter, and thus were probably executed in late 1893 or early 1894, since he exhibited one of these in April–May 1894 at the National Academy of Design in New York. Twachtman's Ni-

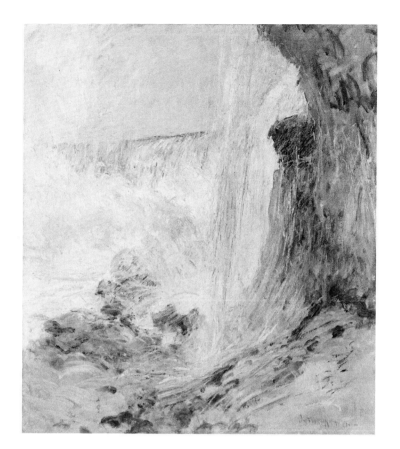

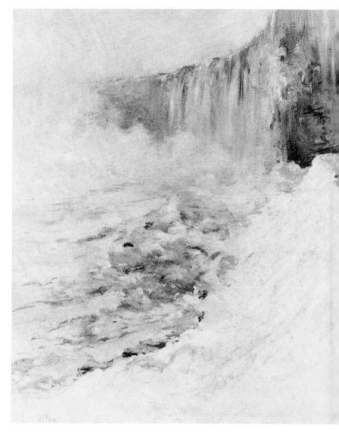

agara pictures are painted in the highest-key palette he ever used. The bright purples, intense pinks, and turquoises evident in works such as *Niagara Falls* (fig. 21) and *Niagara in Winter* (fig. 22) suggest that he may have been particularly receptive to the paintings of Monet he had seen in May 1893. Twachtman's extremely loose brushwork in the Niagara paintings also seems related to Monet's method. However, as in the case of his other works, Twachtman's handling complied with his feeling for the subject, and the scale and force of the falls may have been the main motivation behind the vigor of his approach. The experience of Niagara appears to have been a liberating one for the artist. The monumentality of the site and the rushing cascade allowed him to advance his exploration of light and movement. Twachtman's *Niagara in Winter* was understood by a contemporary critic as a work "in which the artist did not attempt to express the vastness and majesty of the scene, but contented himself with rendering the lovely green and purple tones of the water with the surge and swirl below it, and the further contrast of these moving masses with the smoky lightness of the wind-blown mist and spray."[83]

In the works created for the other major commission he received during the Greenwich years, a number of depictions of Yellowstone Park, Twachtman strengthened and simplified his compositions. Turning away from the highly detailed and panoramic views of Yellowstone painted by Thomas Moran and others, Twachtman trans-

ABOVE LEFT: fig. 21. John Twachtman, *Niagara Falls,* c. 1893–1894. National Museum of American Art, Smithsonian Institution, Washington, Gift of John Gellatly

ABOVE: fig. 22. John Twachtman, *Niagara in Winter,* c. 1893–1894. New Britain Museum of American Art, Connecticut

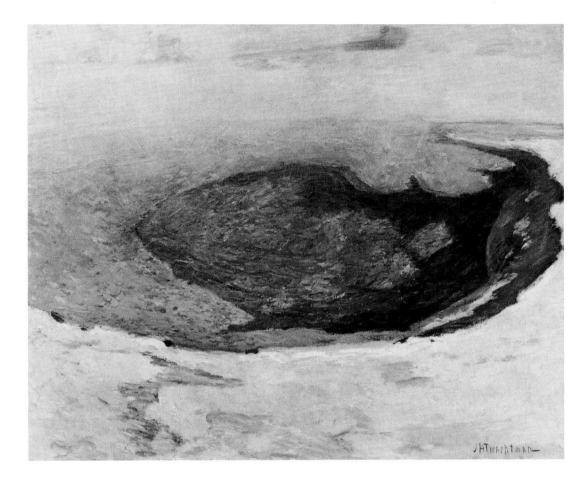

fig. 23. John Twachtman, *Emerald Pool,* c. 1895. Wadsworth Atheneum, Hartford, Connecticut, The Ella Gallup Sumner and Mary Catlin Sumner Collection

lated the stark and dramatic western landscape into extremely minimal and abstract arrangements. He spent much of September 1895 in the park and was exhilarated by the experience, as he indicated in a letter to his patron, Major William A. Wadsworth:

> I am so overwhelmed with things to do that a year could be a short stay. Your reply to my telegram came and I thank you for your liberality. This trip is like the outing of a city boy to the country for the first time. I was too long in one place. This scenery too is fine enough to schock [sic] any mind. We have had several snowstorms and the ground is white—the cañon looks more beautiful than ever. The pools are more refined in color but there is much romance in the falls and the cañon. I never felt so fine in my life and am busy from morning until night. One can work so much more in this place—never tiring. My stay here will last until the first, perhaps I want to go to Lower Falls, they are very fine. There are many things one wants to do in this place.[84]

The three subjects Twachtman took up in Yellowstone are treated in very different ways. The waterfalls are portrayed in the most straightforward and conventional manner, the canyons as powerful arrangements of high rock walls and ribbonlike rivers, and the pools as bold, abstract designs. The fact that Twachtman created the waterfall pictures for a patron possibly accounts for their more traditional presentation.[85] Painting the other subjects for himself, he felt a greater freedom to experiment. Twachtman's depictions of the Yellowstone pools are remarkably abstract for their era, offer-

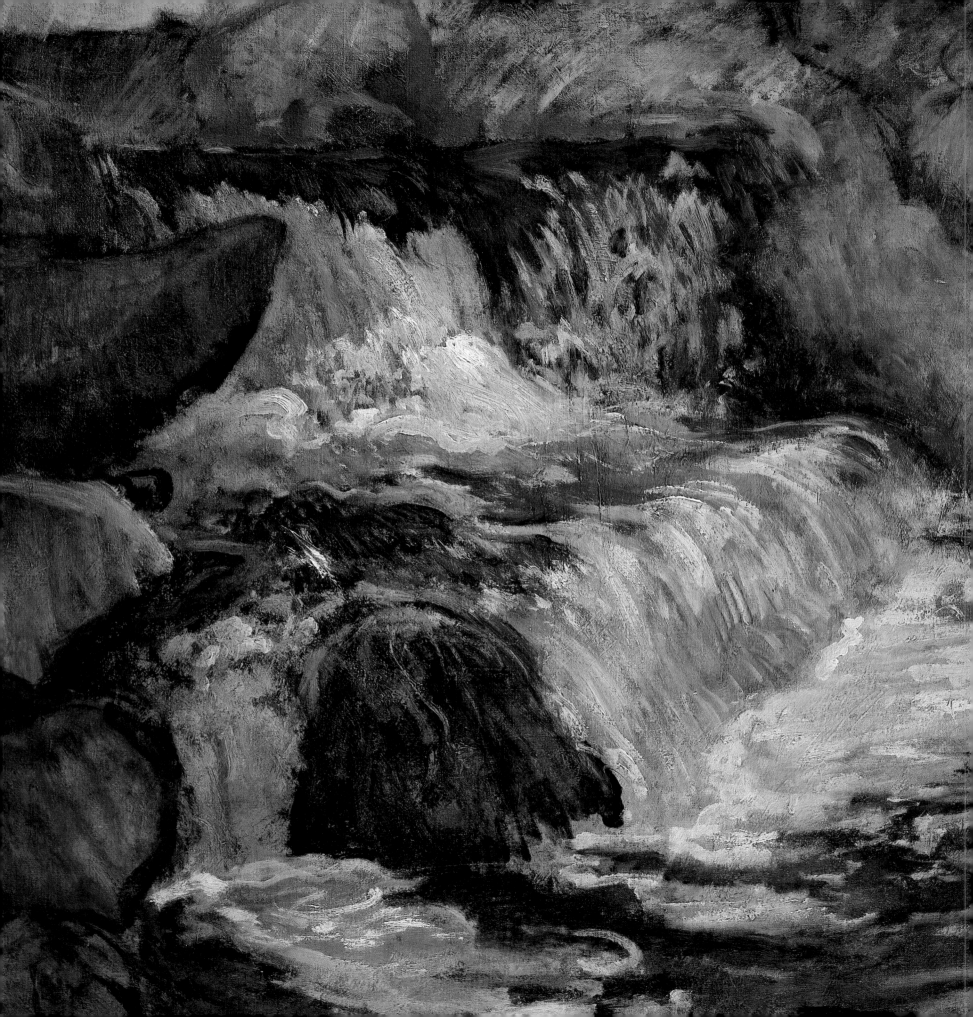

cat. 22. John Twachtman, *The Cascade* (detail), late 1890s. Collection IBM Corporation, Armonk, New York

ing frontal views of the watery chasms, which appear large in scale and surrounded by flat and undifferentiated stretches of terrain (fig. 23). No indication is given of the dimension or depth of the landscape, and no details are included to provide perspective.

The dynamic brushwork and high-key palette of Twachtman's Niagara paintings and the abstract design of his Yellowstone work contributed to his last Greenwich phase. This term was marked by three one-man exhibitions held in 1901, at the Art Institute of Chicago in January, at the Durand-Ruel Galleries in New York in March, and at the Cincinnati Art Museum in April. These shows included a great many of the same works. Twachtman exhibited no pastels in 1901, and the majority of the paintings shown in all three exhibitions were scenes of Gloucester, Massachusetts, where the artist had spent the previous summer. Hale called the final phase of his career the Gloucester period because it is distinguished by the new stylistic approach evident in his paintings of that town.[86] Twachtman combined many of the stylistic elements of earlier periods to arrive at his Gloucester mode: the confident brushwork of his Munich period, the interest in abstract design evident in his French works, and the use of a relatively dry brush and the light palette of his Greenwich years. The Gloucester manner is also characterized by a new *alla prima,* as well as the restoration of black to his palette, which Twachtman had rejected after his Munich period. Although these traits are the most pronounced in the works the artist created in Gloucester, where the brilliant light and picturesque aspects of the coastal town inspired him, many of them are also evident in paintings made in Greenwich at the turn of the century, and a general "marked strengthening" of Twachtman's style becomes apparent in his late Greenwich oils.[87]

Many of the artist's paintings of the waterfall on his Greenwich property demonstrate the greater clarity of design and the active use of paint that emerge in the works of his last years. Although it has been recorded that the falls had been a major inducement in his choice of the tract of land he purchased, he did not exhibit a waterfall subject until 1894, which was described as "excellent in the rush and fall of the water," and of which the upper part was called "somewhat disturbing and cold in color."[88] Eliot Clark made a distinction between Twachtman's first waterfall scenes and those he painted later:

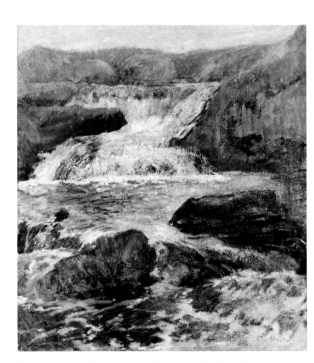

fig. 24. John Twachtman, *Horseneck Falls,* mid-1890s. The Metropolitan Museum of Art, New York, Bequest of Miss Adelaide Milton de Groot (1876–1967), 1967

> The first studies are the most naturalistic, studies of a particular waterfall having the ordinary aspect of the ordinary waterfall. Later, the forms are enlarged and simplified, the angle of vision is reduced, the perspective is limited, a single aspect is pictured, and the action of the water is represented, not by a faithful and naturalistic rendering of the surface qualities of water, but by selecting the most expressive forms and so arranging the design that these forms are an integral and structural part of the composition. The waterfall in the nearby woods thus becomes aesthetically as important as the overwhelming immensity of Niagara. The artist has seized the universal in the particular.[89]

Clark did not specify which of the waterfall paintings were executed first. However, there are notable differences between *Horseneck Falls* (fig. 24) and *The Cascade*

(cat. 22), and it is likely that the former belongs to the earlier mode described by Clark, and the latter to the later. Composed of olive greens, browns, and grays, the palette of *Horseneck Falls* is much darker than that of *Cascade,* in which bright colors and strong contrasts predominate. In the former painting the falls are set back, and the landscape beyond, although treated somewhat sketchily, suggests a spatial context for the image. The latter painting, in contrast, is less naturalistic. The falls are depicted from the side and close up. In *Horseneck Falls* the falls appear to be monumental. In *The Cascade* no sense of their scale is provided; although the painting conveys the force of the water and its varying rhythms, in it Twachtman was also concerned with the physical material of paint itself, and the work breaks down into myriad patterned and textural effects.

Twachtman's close-up images of waterfalls probably date from around the turn of the century. A painting of this subject received an honorable mention at the Carnegie Institute in its annual exhibition held in November–December 1899, and he included a waterfall painting in two 1900 one-man shows, at the St. Botolph Club in Boston and at the Cincinnati Art Museum. *Waterfall, Blue Brook* (cat. 21), featured in the Cincinnati display, is the only painting by Twachtman that a museum bought during his lifetime.[90] He may have been concentrating on waterfalls in those years, as he displayed several in his 1901 exhibition at Durand-Ruel.

The strong design and "increased personal force" a *New-York Daily Tribune* critic recognized in the work of Twachtman's late years may also be found in other Greenwich paintings.[91] Although the early history of the painting is not known, it is likely that *Snow* (cat. 13), a view that includes the barn on Twachtman's property, dates from the late Greenwich years. Its subject is the same as that depicted in *Winter* (cat. 12), but the shapes within the scene are more clearly geometric, and carefully organized rather than softly merged into the landscape. Whereas in *Winter* nature appears empty and barren, in *Snow* it seems inhabited by the barn, the commanding element within the scene, which controls the surrounding countryside.

In *Hemlock Pool* (cat. 5) the decisiveness of Twachtman's late style is also evident. It was probably this picture of the pool that was included in his 1901 shows in New York and Cincinnati. A *New York Times* reporter wrote: "To see him at his best is to look at the 'Hemlock Pool,' with slopes all snowy, but set with brown bushes and trees and the water of the brook fringed with white ice."[92] Another New York reviewer wrote that the artist's paintings would "bid fair to improve with time. In the 'Hemlock Pool,' seen many times before, one already notices a ripening of tone and increasing coherence of effect."[93] *Hemlock Pool* demonstrates some essential departures from other depictions of the subject such as *Icebound* (cat. 2) and *Winter Harmony* (cat. 1). For example, the band of snow that lines the pool serves to tighten the composition. Instead of the oblique viewpoint and atmospheric effects in *Winter Harmony, Hemlock Pool* possesses a sense of immediacy created by the frontal presentation, the vertical emphasis, and simplification of the composition.

Twachtman's late style is also revealed in his views from the front of Holley House in Cos Cob. None of these appear to have been included in the 1901 exhibitions, and it

fig. 25. John Twachtman, *Old Holley House, Cos Cob,* c. 1901. Cincinnati Art Museum, John J. Emery Endowment

fig. 26. John Twachtman, *October,* c. 1901. The Chrysler Museum, Norfolk, Virginia, Gift of Walter P. Chrysler, Jr.

is probable that they were executed during that year, when Twachtman stayed for several long periods at the inn.[94] He could not have made them before 1899, when a mill that blocked the view burned down. In a letter to his son, J. Alden (who was at the time studying at the Yale University Art School in New Haven), he described the inspired manner in which he worked: "Yesterday I painted all day looking from a window at the blizzard and it recalled the one we had at home but not so fierce. But it was beautiful and I could not stop painting and painted until it was too dark to see and I was tired out. It seemed to be a fifty round go and I got knocked out at about the eleventh round."[95]

The paintings from the Holley House present the same vista, although seen from slightly different angles. Yet each small shift in his position provided the artist with different compositional opportunities and contributed to the emotional expression of the works. In *From the Holley House, Cos Cob* (cat. 25), a palette of soft pastels and delicate treatment of forms conveys the freshness of spring. Twachtman achieved balance in the painting by creating a dialogue between surface and depth, a push-pull effect. The red building stands in the distance, yet its bright color brings it forward. The lilac bushes shown in the foreground seem to merge with the landscape beyond. The angled opening in the porch is echoed by the square red building, which is in turn repeated by the shape of the canvas. In *Bridge in Winter* (cat. 24) a hushed calm is created, similar to the feeling expressed in the earlier *Winter Harmony*. But in the later work, rather than primarily making use of soft tonal values, Twachtman manipulated the composition for impact. The bridge, shown more frontally than in the spring scene of the same motif, leads one into the distance at a slow pace. The lilacs are centered and less active than in the spring view, conveying a staid effect; the strong horizontals also express stasis and tranquility. In *View from the Holley House, Winter* (cat. 26), Twachtman created air that is heavy with the thick mist that anticipates a new snowfall. Here, too, horizontals dominate the composition, and although no lilac bushes were included in the foreground as counterpoint, the arrangement is balanced by the two thin vertical poles that stand in front of the low warehouse structure on the right, and by their reflections in the water below.

Old Holley House, Cos Cob (fig. 25) is another painting Twachtman made in Cos Cob during the first few months of 1901.[96] Long thick strokes of white and blue paint and the canvas ground, which is left bare in spots, add contrast and texture. The strong repeating horizontals of the roof are broken up by the vertical of the tree in the foreground, its spidery branches reiterated in the swirling strokes that describe the ground. In *October* (fig. 26), Twachtman used very sketchy and free brushwork, relating the feathery branches of trees and grasses to the delicate lines of the double-tiered porch of the Brush house (which stood next to the Holley House) and the columned veranda of the small grocery beside it.

Another distinguishing feature of Twachtman's late Greenwich works lies not in the realm of stylistic innovation but in attitude and choice of subject. A change in the artist's outlook toward nature becomes apparent in a number of works that can be dated mostly to the late 1890s. These works reveal a new humanized, tempered view of

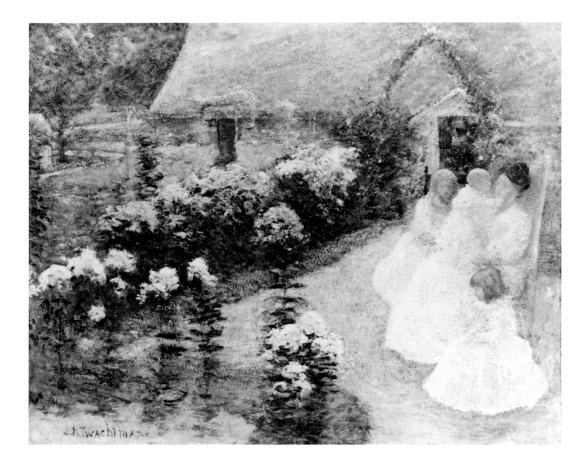

fig. 27. John Twachtman, *On the Terrace*, c. 1897. National Museum of American Art, Smithsonian Institution, Washington, Gift of John Gellatly

the landscape, in contrast to the delicate pastels and the paintings of the early 1890s in which the outdoor environment is desolate and wild. The panoramic landscape *Summer* (cat. 16) can safely be assigned to the late 1890s, since the second dormer that appears on the roof is not present in other versions of the subject. The house nestled in the hillside and presiding over an open sun-filled meadow conveys the feeling of ease, comfort, and pleasure; it occupies a civilized landscape. A similar attitude is apparent in *From the Upper Terrace* (cat. 15), a painting displayed in the first exhibition of The Ten in 1898 and in all three of Twachtman's 1901 shows. In this work, the house is also comfortably situated on the hillside. The many curved pathways leading to it draw us through an inviting, cultivated, gardenlike setting. *On the Terrace* (fig. 27), also shown in the first exhibition of The Ten in 1898, speaks perhaps most fully of the satisfaction that Twachtman took in his home and family in his late Greenwich years.

In the late 1890s Twachtman also began depicting his residence from a new vantage point—the front with its classical portico designed by the architect Stanford White. In these works, the house assumes a more stately appearance than in contemporaneous paintings of the back of the house. In *The Portico* (fig. 28), the elegance of the building with its columned facade and carefully tended potted plants is matched by a strong, balanced composition, crisply defined areas of color, and a golden light that suffuses the scene. In proportion to the figures who stand on the porch, the house appears

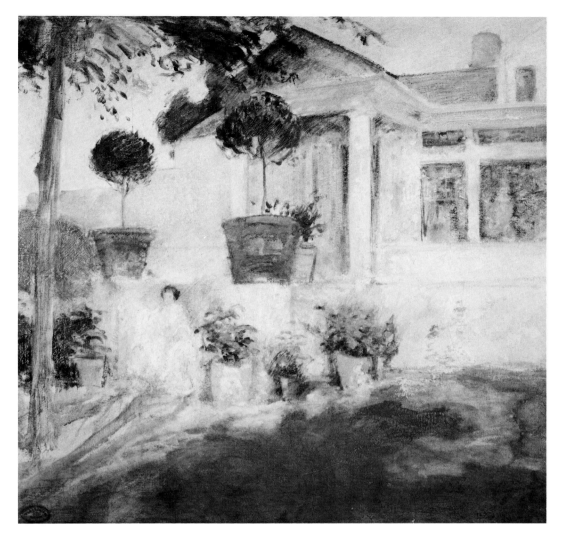

fig. 28. John Twachtman, *The Portico,* late 1890s. Private collection

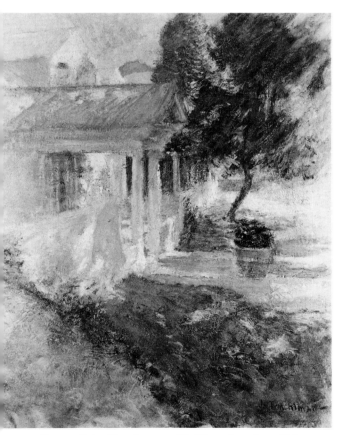

fig. 29. John Twachtman, *My House,* late 1890s. Yale University Art Gallery, New Haven, Gift of the Artist

large in scale. Twachtman expressed its ability to provide shelter and security. *My House* (fig. 29), which also suggests the comforting refuge offered by his domicile, may be the painting of this title shown in the third exhibition of The Ten in 1900 and in 1901 at Durand-Ruel. A critic described *My House* shown in 1901 as "a white house—very deliciously painted is its portrait too—and through the arbors and porch sunlight falls in broad yellow streaks. . . ."[97]

The paintings of the white footbridge, which Twachtman had constructed in the mid-1890s over a low section of Horseneck Brook, also demonstrate his new interest in a humanized view of nature. Although a painting titled *The Bridge* was shown in two 1896 exhibitions, we do not know that a depiction of the white bridge was exhibited until mid-1897, when Twachtman entered *The White Bridge* in the National Academy of Design annual. He also included a canvas titled *The New Bridge* as one of his six entries in the first exhibition of The Ten in 1898.

fig. 30. John Twachtman, *Misty May Morn,* 1899. National Museum of American Art, Smithsonian Institution, Washington, Gift of John Gellatly

There are five known white bridge paintings and each is very different, a testament to the wide stylistic variety of Twachtman's last phase. In *The White Bridge* (cat. 19), the latticed structure is set in the midst of dense foliage, contributing to the delicate, overlapping web of forms. In the version in the Art Institute of Chicago (cat. 18), the bridge takes on another character altogether, becoming a means of animating the landscape. That painting may have been the work called *The New Bridge,* shown in 1898, described by a critic as "extremely deft in its expression of the freshness of the trees, the brightness of the color, the movement of the brook which crosses the canvas."[98] In comparison to these two paintings of the bridge, the rendering in the Memorial Art Gallery, Rochester (cat. 20) is painted in the more direct *alla prima* method of Twachtman's last years, and so is thought to postdate the other versions.

During Twachtman's last Greenwich phase he also rendered works expressive of more ethereal aspects of nature, such as *Misty May Morn* in 1899 (fig. 30), the only painting that Twachtman definitely dated during his Greenwich years. Delicate layers of paint, in which light colors blend together, express the thick atmospheric veil that fills the landscape at dawn on a spring day. *Misty May Morn* is undoubtedly the painting shown with the title *Morning* in the second exhibition of The Ten, about which a

New York Sun critic wrote: "Mr. Twachtman . . . sends one picture 'Morning,' that is much finer than anything he showed at the first exhibition of the Ten. The atmosphere of the dawn is exquisitely expressed; there is a delicate poetic feeling in the picture not always found in the work of Mr. Twachtman."[99]

Twachtman's emotional responses to nature motivated his art. Varying his methods of paint application, color schemes, and compositions, he conveyed his direct reactions to his subjects, capturing the different qualities of each season. Over the course of the Greenwich years, basic shifts occurred in Twachtman's approach as well as in his attitude toward nature. As those years progressed, his family expanded and he gradually added to his home and cultivated his property. In correspondence to these changes, his paintings convey an increasing sense of settlement, security, and confidence. In his first phase, 1889–1891, he presented wild and isolated sites, communicating an awe of nature and expressing its poetry and subtle, mysterious qualities. During his second phase, 1891–1896, he began to render his subjects in a more immediate manner, capturing effects of light and atmosphere, and bringing out patterned arrangements that the landscape suggested to him. Finally in his third phase, 1897–1902, he achieved a sense of equilibrium with nature, and the canvases of this time convey a greater self-assurance. As a *New-York Daily Tribune* reporter recognized, in Twachtman's last years his "ideas underwent a clarifying process, his hand became firmer as his vision became more acute, and in the paintings of the period he showed that he had travelled far from the uncertainties of his earlier experiments. His work became stronger in design, more attractive in color and more delicate in atmosphere. At the same time his art increased in personal force."[100] During the artist's final period he relied to a greater degree than previously on compositional means for expression, and a new humanized, tempered view of the outdoor environment emerges.

Throughout his career, Twachtman was at the forefront of American avant-garde art movements, and the critics repeatedly commented on the modernity of his work. The strength and beauty that captured their attention is still evident in his art today.

Notes

Many people assisted me in my research on Twachtman and on this essay. I would especially like to thank Professor William H. Gerdts for his guidance and support. Ira Spanierman, David C. Henry, Carol Lowrey, Jean M. Carlson, Stephen R. Edidin, Diana Murphy, David Dearinger, and Jennifer Firestone also provided vital contributions. The studies carried out on Twachtman thus far have constituted an important basis for this undertaking, and I am indebted to the insightful and perceptive writings of Eliot Clark, John Douglass Hale, Richard J. Boyle, and William H. Gerdts. See Eliot Clark, "John Henry Twachtman (1853–1902)," *Art in America* 7 (April 1919), 129–137; Eliot Clark, "The Art of John Twachtman," *International Studio* 72 (January 1921), lxxvii–lxxxvi; Eliot Clark, *John Twachtman* (New York, 1924); John Douglass Hale, *The Life and Creative Development of John H. Twachtman,* 2 vols., Ph.D. diss., Ohio State University, 1957, (Ann Arbor, 1957), microfilm; Richard J. Boyle, "Introduction," *A Retrospective Exhibition* [exh. cat., The Cincinnati Art Museum] (Cincinnati, 1966); Richard J. Boyle, *John Twachtman* (New York, 1979); William H. Gerdts, *American Impressionism* (New York, 1984).

1. Although Twachtman had known Duveneck through mutual ties in the German community in Cincinnati, he came into closer contact with the slightly older artist when he joined the evening class Duveneck taught as a special instructor at the Ohio Mechanics Institute in 1874–1875. Among the students in the class were Joseph De-Camp, Kenyon Cox, Clement J. Barnhorn, and Alfred Brennan. See Clement J. Barnhorn, Cincinnati, to John H. Faig, Ohio Mechanics Institute, Cincinnati, 11 June 1930, Archives, University of Cincinnati. For further information on Duveneck in Munich, see Michael Quick, *An American Painter Abroad: Frank Duveneck's European Years* [exh. cat., Cincinnati Art Museum] (Cincinnati, 1987); Robert Neuhaus, *Unsuspected Genius: The Art and Life of Frank Duveneck* (San Francisco, 1987); *Munich and American Realism in the 19th Century,* essays by Michael Quick and Eberhard Ruhmer, catalogue by Richard V. West [exh. cat., Crocker Art Gallery] (Sacramento, 1978).

2. Twachtman registered on 15 October 1875 at the Royal Academy, Munich, enrolling in "ein Naturklasse." See Matriculant's Book, Academy of Fine Arts, Munich.

3. For information on the Tile Club, see Constance Koppelman, *Nature in Art and Culture: The Tile Club* (Ph.D. diss., State University of New York, Stonybrook, 1985); Ronnie Rubin, *The Tile Club,* 1877–1887 (M. A. thesis, New York University, Institute of Fine Arts, 1967); Mahonri Sharp Young, "The Tile Club Revisited," *American Art Journal* 2 (Fall 1970), 81–91. There are also many contemporary articles on the Tile Club, including William Mackay Laffan, "The Tile Club at Work," *Scribner's Monthly Magazine* 17 (January 1879), 401–409; William Mackay Laffan and F. Hopkinson Smith, "The Tile Club at Play," *Scribner's Monthly Magazine* 17 (February 1879), 457–468; William Mackay Laffan and F. Hopkinson Smith, "The Tile Club Afloat," *Scribner's Monthly Magazine* 19 (March 1880), 641–670; "The Tile Club at Play," *Century Magazine* 23 (February 1882), 481–498. See also Edward Strahan [Earl Shinn and F. Hopkinson Smith], *A Book of the Tile Club* (New York, 1886).

4. From spring 1882 until winter 1883, Twachtman lived in the Cincinnati suburb of Avondale where his wife's father resided. Martha Scudder Twachtman's father was the well-known physician John Milton Scudder (1829–1894), who taught at the Eclectic Medical Institute in Cincinnati and wrote many medical treatises.

5. During his trip to Holland in the summer of 1881, Twachtman stayed in the Dordrecht area in southern Holland, where he visited J. Alden Weir and his brother John Ferguson Weir. It was also during this trip that he met the Hague School painter Anton Mauve, who criticized his work. See Hale 1957, 1:45; Clark 1924, 23.

6. J. H. Twachtman, Paris, to [J. Alden] Weir, [location unknown], 7 December 1883, Weir Family Papers, MSS 41, Harold B. Lee Library, Archives and Manuscripts, Brigham Young University, Provo, Utah.

7. Twachtman completed the last months of his French period in Venice where he spent much time with American artist Robert Blum. Twachtman was still in Venice on 26 December 1885. He wrote to William Merritt Chase at the time: Otto Bacher Papers, Archives of American Art, Smithsonian Institution, frames 9–10. On 22 January 1886 Blum indicated in a letter to Otto Bacher that Twachtman had left Italy: Otto Bacher Papers, Archives of American Art, Smithsonian Institution, frames 200–202.

8. Eliot Clark wrote that the cyclorama on

which Twachtman worked had depicted the Battle of Gettysburg; however, as Hale discovered, this project had already been completed by early 1884. Twachtman may have assisted instead on a cyclorama of the Battle of Montretout, which was initiated in 1884. See Clark 1924, 26; Hale 1957, 1:63; and Carolyn Mase, "John H. Twachtman," *International Studio* 72 (January 1921), lxxiii.

9. Anna Falconnet Hunter (1855–1941) was an artist and art teacher who resided in Newport. She wrote in her journal on 21 June 1889, "Studio in morning. Mr. Twachtman wishes us to begin big canvas out of doors." Hunter Family Diaries, box 98, vault A, Newport Historical Society. Information on Twachtman's outdoor instruction is also included in *Retrospective Exhibition of the Work of Artists Identified with Newport* [exh. cat., The Art Association of Newport] (Newport, Rhode Island, 1936), 28. For a comprehensive discussion of the development of outdoor painting in America, see William H. Gerdts, "The Teaching of Painting Out-Of-Doors in America in the Late Nineteenth Century," *In Nature's Ways* [exh. cat., Norton Gallery of Art] (West Palm Beach, Florida, 1987), 25–40.

10. See Gerdts 1987, 31–32; and Gerdts 1984, 130.

11. In the catalogue for the ninth annual exhibition of the Society of American Artists in April–May 1887, Twachtman's address appears as care of J. Alden Weir, 11 East Twelfth Street. He was listed at 80 East Washington Square (the Benedict building) in the catalogues for exhibitions that occurred in the following two years: the 63d annual exhibition at the National Academy of Design in April–May 1888; the tenth annual exhibition of the Society of American Artists in April–May 1888; the 16th annual Inter-State Industrial Exposition in Chicago in September 1888; the second annual exhibition of the Art Institute of Chicago in June 1889. On the Benedict building (also known as the University Building), see Theodore Francis Jones, ed., *New York University: 1832–1932* (New York, 1933), 393–398; Paul R. Baker, "The Cultural and Bohemian Community," *Around the Square* (New York, 1982), 64–73. Twachtman's Greenwich address is given for the first time in the catalogue for the third annual exhibition of the Art Institute of Chicago in June–July 1890.

12. In her typescript of an undated letter from Twachtman to Weir in which Twachtman wrote "We go to Cos Cob to-morrow to board for a while and hope that our credit will be good there," Dorothy Weir Young, daughter of J. Alden Weir, indicated that the letter had been posted 12 September 1886. (See Twachtman to Weir, [12 September 1886], Weir Family Papers.) However, when the original of this letter was recently inspected, it was discovered that the envelope that must have once accompanied it no longer exists. When the full contents of the document are considered in the context of Twachtman's Greenwich years, it seems more likely that the letter was written when Twachtman was already settled on Round Hill Road and staying periodically at the Holley House in Cos Cob. Twachtman only began to write with the large and free handwriting style that appears on the letter in the late 1890s. His handwriting in dated correspondence of the late 1880s and early 1890s is small and tight in comparison. Twachtman's discovery of his Greenwich property is discussed in Hale 1957, 1:69–70; and Clark 1924, 27.

13. Hale 1957, 1:69–70.

14. Twachtman probably lived first as a tenant on the property, which was known as Hangroot, since he did not purchase it until 1890–1891. The acquisition of the property was made in two installments; see Warantee Deeds, Greenwich Town Hall, 7 March 1890, book 60, 236 (first purchase of land, 3-acre plot); 1 December 1891, book 61, 488 (second purchase of land, 13.4-acre plot). See also Susan G. Larkin, "The Cos Cob Clapboard School," *Connecticut and American Impressionism* [exh. cat., The William Benton Museum of Art, University of Connecticut] (Storrs, Conn., 1980), 89.

15. Alfred Henry Goodwin, "An Artist's Unspoiled Country Home," *Country Life in America* 8 (October 1905), 625–630.

16. See Hale 1957, 1:72–76; Goodwin 1905, 625–630.

17. There are no contemporary documents providing a record of the construction of the portico. See Hale 1957, 1:79.

18. See Hale 1957, 1:72–73.

19. "John H. Twachtman: Death of the Famous Landscape Painter at Gloucester, Massachusetts," *New York Times* (9 August 1902), 9.

20. Reported in Clark 1924, 58.

21. According to Hale, J. Alden, Twachtman's son, recalled his father returning four or five times to a site before he finished a picture. See Hale 1957, 1:265, 268. Clark also discussed Twachtman's Greenwich painting procedure; see Clark

1924, 59.

22. Childe Hassam, "John H. Twachtman: An Estimation," *North American Review* 176 (April 1903), 555.

23. In his diaries, Theodore Robinson made note of Twachtman's interest in Japanese art. Among other entries, he wrote on 31 October 1893: "some talk about the Jap[anese] Ex[hibition] at the Museum, that T[wachtman] is most enthusiastic about," and on 10 December of the same year, he recorded a dinner conversation he had with Twachtman and Weir: "We discussed Japanese Art and other . . . Tw[achtman] & W[eir] are rabid just now on the j[apanese]." Theodore Robinson Diaries, Frick Art Reference Library, New York.

Art Nouveau may have had an impact on Twachtman in the mid-1890s, as in the decorative graphic designs he created at the time he made use of simplified designs and the curving linear patterns typical of the French style. Twachtman's only known poster was published by Stone and Kimball (New York and Chicago) in 1896. It advertised Harold Frederic's book, *The Damnation of Theron Ware.* Twachtman's book covers were created for two novels by William Canton that were also published by Stone and Kimball in 1896: *W. V. Her Book,* and *The Invisible Playmate.* See *American Art Posters of the 1890s in the Metropolitan Museum of Art,* including the Leonard A. Lauder Collection (New York, 1987), essays by Phillip Dennis Cate, Nancy Finlay, and David W. Kiehl, and catalogue by David W. Kiehl.

24. For a discussion of American artists' use of the square format, see William H. Gerdts, "The Square Format and Proto-Modernism in American Painting," *Arts Magazine* 50 (June 1976), 70–75.

25. See Hale 1957, 1:81–85. Branchville was easily reached by train.

26. See Hale 1957, 1:85. Many entries in Robinson's diaries of 1892–1895 mention visits with Twachtman in Greenwich. See Theodore Robinson Diaries, Frick Art Reference Library, New York.

27. Hale 1957, 1:83. Hassam's painting, *Two Children* (1897, Cincinnati Art Museum) is thought to depict the interior of Twachtman's home and two of his daughters.

28. In 1895, Robert Reid displayed a painting titled *Twachtman's Valley at Sunset* in the seventeenth annual exhibition of the Society of American Artists. The *Art Amateur* reported: "Mr.

Twachtman's country place seems to be a regular rendezvous for Impressionists. It has already been painted by several, and now Mr. Robert Reed [sic] adds his testimony to its attractions. . . ." *Art Amateur* 32 (May 1895), 158. Robinson painted at least two canvases on Twachtman's property, *Twachtman's House,* 1892, and *The Stepping Stones,* the latter including portrayals of two of Twachtman's daughters, Marjorie and Elsie, walking across Horseneck Brook.

29. See *Twachtman in Gloucester: His Last Years, 1900–1902* [exh. cat., Spanierman Gallery] (New York, 1987), essays by John Douglass Hale, Richard J. Boyle, and William H. Gerdts; and Hale 1957, 1:263–280.

30. Information on Twachtman's teaching activities in Cos Cob may be found in Gerdts 1987, 32–33; Larkin 1980, 89; and Dorothy Weir Young, *The Life and Letters of J. Alden Weir* (New Haven, 1960), 181, 185. A direct account of Twachtman's instruction in Cos Cob is provided in "An Art School at Cos Cob," *Art Interchange* 45 (September 1895), 56–57.

31. Lincoln Steffens, *The Autobiography of Lincoln Steffens* (New York, 1931), 436–438. The Holley House is now occupied by the Historical Society of the Town of Greenwich.

32. Robinson wrote to Harrison Morris, secretary and managing director of the Pennsylvania Academy, that "Poor Twachtman has had an awful time—Scarlet fever in his family—his little Elsie, 8 [sic] years old, died Saturday and was buried Mon. a.m. Weir was at the funeral, the only one I believe. T. is now with his family and it will be some time before they are out of all danger." Robinson to Morris, 17 January 1895, Archives, Pennsylvania Academy of the Fine Arts, Philadelphia.

33. On Twachtman's poor health in the 1890s, see the letter from Thomas Dewing to Stanford White cited in Charles C. Baldwin, *Stanford White* (New York, 1931), 373 (original letter is unlocated).

34. A great many of Twachtman's works were still in his possession at the time of his death, especially those he had created during his Greenwich period. A sale of his estate was organized in 1903 by a number of his close friends and his few important patrons. See *Catalog of the Work of the Late John H. Twachtman* [sale cat., American Art Galleries] (New York, 1903). Subsequent sales of works from his estate were sold in the following years: See *Memorial Exhibition of*

Pictures by John H. Twachtman [exh. cat., Knoedler Galleries] (New York, 1905); *Exhibition of Paintings by John H. Twachtman* [exh. cat., Macbeth Gallery] (New York, 1919); *Exhibition of Paintings by J. H. Twachtman* [exh. cat., Vose Galleries] (Boston, 1919).

35. J. Alden Weir to C. E. S. Wood, 18 September 1902, J. Alden Weir Papers, Archives of American Art, roll 125, frame 916.

36. J. Alden Weir, "John H. Twachtman: An Estimation," *North American Review* 176 (April 1903), 561.

37. Thomas Dewing, "John H. Twachtman: An Estimation," *North American Review* 176 (April 1903), 554.

38. According to Clark 1924, 26; Hale 1957, 1:63; and Young 1960, Twachtman rented a house in Branchville during the summer of 1888. Doreen Bolger Burke, in *J. Alden Weir: An American Impressionist* (Newark, New Jersey, 1983), 169, indicated that Twachtman rented in Branchville in the summer of 1887. Twachtman may, however, have stayed in Branchville during both summers.

39. Twachtman's property was referred to as a "certain lot piece or parcel of land at Hangroot" in the mortgage deed on his first purchase of land in Greenwich. See Warantee Deeds, Greenwich Town Hall, 18 February 1890, book 63, 10.

40. *Icebound* (Art Institute of Chicago), often cited as the first Greenwich painting that Twachtman exhibited, is thought to have been shown in the second annual exhibition of The Art Institute of Chicago in June 1889. See James L. Yarnall, "John H. Twachtman's Icebound," *Bulletin of the Art Institute of Chicago* 71 (January–February 1977), 2–4. However, the evidence that the painting currently in the Art Institute's collection is the one that was shown is inconclusive. It is not likely that Twachtman was a resident of Greenwich before the fall of 1889, and thus he would not have painted the subject before this time. In addition, since *Icebound* (known until 1977 as *Snowbound*) did not enter the Art Institute's collection until 1917, its earlier history cannot be verified. In fact, since Twachtman is known for his constant reuse of titles, the painting shown could very well have been another work. There are no reviews of the exhibition that provide a description of it. A very odd aspect of the painting is that it appears to be dated 1884, an inconceivable date. Possibly it was meant to read 1889. However, since there are almost no dated works from the Greenwich years, the date that

appears is suspect, and cannot be used as a definitive basis for research.

41. For further information, see Dianne H. Pilgrim, "The Revival of Pastels in Nineteenth-Century America: The Society of Painters in Pastel," *American Art Journal* 10 (November 1978), 43–62.

42. "Painters in Pastel," *New York Times* (5 May 1890), 4.

43. See "Art Notes," *New York Times* (9 March 1891), 4; "Art Notes," *New York Times* (12 April 1891), 12.

44. "Art Notes," *New York Times* (9 March 1891), 4.

45. "In the Art World," *New York World* (15 March 1891), 15.

46. *"Notes"—"Harmonies"—"Nocturnes,"* [exh. cat., Wunderlich Gallery] (New York, 1889). Only watercolors and pastels were included in this show.

47. "Mr. Whistler's Pictures at the Wunderlich Gallery," *New York Sun* (10 March 1889), 14.

48. "A Criticism," *Studio* 6 (25 April 1891), 203.

49. "Art Notes: Pictures by J. H. Twachtman at Wunderlich," *New York Evening Post* (9 March 1891), 7.

50. "Art Notes: Pictures by J. H. Twachtman at Wunderlich," *New York Evening Post* (9 March 1891), 7.

51. "Art Notes," *New York Times* (9 March 1891), 4.

52. "The World of Art: An Impressionist's Work in Oil and Pastel—Mr. Twachtmann's [sic] Pictures," *New York Mail and Express* (26 March 1891), 3.

53. See Hale 1957, 1:213.

54. "Art Notes: Pictures by J. H. Twachtman at Wunderlich," *New York Evening Post* (9 March 1891), 7.

55. "Art News and Comments: The Week in Art Circles," *New-York Daily Tribune* (17 March 1889), 15.

56. "My Notebook," *Art Amateur* 24 (April 1891), 116.

57. "Paintings in Oil and Pastels by J. H. Twachtman," *Studio* 6 (28 March 1891), 162.

58. "Art Notes," *New York Times* (9 March 1891), 7.

59. A Criticism, *Studio* 6 (25 April 1891), 203.

60. "Art Notes: Pictures by J. H. Twachtman at Wunderlich," *New York Evening Post* (9 March 1891), 7.

61. "My Notebook," *Art Amateur* 24 (April

1891), 116.

62. "Art Notes: Pictures by J. H. Twachtman at Wunderlich," *New York Evening Post* (9 March 1891), 7.

63. "The World of Art: An Impressionist's Work in Oil and Pastel—Mr. J. H. Twachtmann's [sic] Pictures," *New York Mail and Express* (26 March 1891), 3.

64. There are no extant copies of the catalogue from the May 1893 American Art Galleries exhibition of the works of Monet and Besnard. However, newspaper articles list the number of works shown by each artist and provide titles of the paintings. See notes 65, 66, 71.

65. "Some Dazzling Pictures," *New York Times* (4 May 1893), 9.

66. "A Group of Impressionists," *New York Sun* (5 May 1893), 6.

67. "A Group of Impressionists," *New York Sun* (5 May 1893), 6.

68. "Impressionism and Impressions," *Collector* 4 (15 May 1893), 213. Cited in Gerdts 1984, 106.

69. The 1886 exhibition, *Special Exhibition of Works in Oil and Pastel by the Impressionists of Paris,* was shown at both Durand-Ruel Galleries, New York (opening 10 April 1886), and the National Academy of Design, New York (opening 25 May 1886). Another collection of works by the French impressionists, organized by Durand-Ruel, was shown at the National Academy of Design in July 1887. There was no catalogue for this exhibition. For information, see "The Durand-Ruel Collection of Paintings at the National Academy of Design," *Studio* 3 (July 1887), 1–6; "French Paintings at the Academy," *Art Amateur* 17 (July 1887), 32.

70. *Exhibition of Paintings by Old Masters, and Modern Foreign and American Artists, together with an Exhibition of the Work of Monet the Impressionist* [exh. cat., Union League Club] (New York, 1891).

71. Mariana G. van Rensselaer, "Questions of Art," *New York World* (25 June 1893), 9.

72. "A Group of Impressionists," *New York Sun* (5 May 1893), 6.

73. Van Rensselaer 1893, 9.

74. *Mother and Child* and *In the Sunlight* are discussed in John Douglass Hale, "Twachtman in Greenwich: The Figures," *In the Sunlight: The Floral and Figurative Art of J. H. Twachtman* [exh. cat., Spanierman Gallery] (New York, 1989), 37–45. Additional information on *In the Sunlight* is provided in the same catalogue on page 70.

75. The painting *Last Touch of Sun* came to light recently when it was included in a sale at Christies', New York, in December 1986. Labels on its back verify its inclusion in the second annual exhibition at the Carnegie Institute and its ownership by Andrew Carnegie.

76. "French and American Impressionists," *Art Amateur* 29 (June 1893), 4.

77. Theodore Robinson Diary, Frick Art Reference Library, New York, 11 April 1894.

78. "St. Botolph's Exhibition: Paintings by Messrs. Weir and Twachtman on View in Their Gallery," *Boston Evening Transcript* (28 November 1893), 4.

79. Theodore Robinson Diaries, 24 December 1892, Frick Art Reference Library, New York.

80. See "Some French and American Pictures," *New York Evening Post* (8 May 1893), 7.

81. "New Pictures at the Academy," *Philadelphia Inquirer* (16 December 1894), 5.

82. Charles Cary (1852–1931) was a descendant of an important Buffalo family. Cary was a physician and professor of anatomy at the University of Buffalo who was involved in many aspects of the town's academic and social life. According to Eliot Clark, Twachtman created his Niagara paintings while visiting Cary, and as a result of his association with Cary, Twachtman was introduced to Major William A. Wadsworth, of Geneseo, New York, who commissioned the Yellowstone works.

83. "Sale of Evans' Pictures: Art Event of the Week," *New York American* (31 March 1913), 6.

84. J. H. Twachtman, Grand Canyon Hotel, Yellowstone National Park, Wyoming, 22 Sept. 1885, to W[illiam] A. Wadsworth [Geneseo, New York], The Wadsworth Family Papers, College Libraries, State University of New York College of Arts and Science at Geneseo. William A. Wadsworth (1847–1918) was a major in the Spanish American War. He was considered the wealthiest man in the Genesee Valley. His father, James W. Wadsworth, was a senator in the United States Congress.

85. See Hale 1957, 1:254.

86. See New York, 1987; and Hale 1957, 1:263–280.

87. Hale 1987, 1:12.

88. "Society of American Artists: Second Notice," *New York Evening Post* (17 March 1894), 7.

89. Clark 1924, 50.

90. See J. H. Twachtman, 26 April 1900, to Joseph Gest, assistant director, Cincinnati Art

Museum, 26 April 1900, Archives, Cincinnati Art Museum.

91. "John H. Twachtman," *New-York Daily Tribune* (9 August 1902), 8.

92. "A Trio of Painters: Pictures by Three Americans in Three Fifth Avenue Galleries," *New York Times* (7 March 1901), 8.

93. "Around the Galleries," *New York Sun* (6 March 1901), 6.

94. Some receipts from Twachtman's 1901 and 1902 visits at Holley House still exist. He was in residence from 9 October 1901 to 15 January 1902. In 1902 he stayed there from 15 to 19 January, from 29 January to 2 February, from 8 to 25 February, and from 11 April to 30 May. Board Records, Archives, Historical Society of the Town of Greenwich.

95. [John H. Twachtman, Cos Cob, Connecticut, c. winter 1901] to [J.] Alden [Twachtman, Yale University School of Art], Private Collection, Vermont.

96. This painting is illustrated and discussed in Twachtman's letter to his son: [John H. Twachtman, Cos Cob, Connecticut, winter 1901] to [J.] Alden [Twachtman, Yale University School of Art], Private Collection, Vermont.

97. "A Trio of Painters: Pictures by Three Americans in Three Fifth Avenue Galleries," *New York Times* (7 March 1901), 8. *My House* was given to the Yale University Art Gallery by the artist. Yale records indicate that the painting entered the collection in 1887, surely an incorrect date.

98. "Art Exhibitions: 'Ten American Painters,'" *New-York Daily Tribune* (30 March 1898), 7.

99. "Art Notes: Second Exhibition of the Ten American Painters at Durand-Ruel," *New York Sun* (6 April 1899), 6. Other descriptions of Twachtman's *Morning* appeared in reviews of the 1899 Ten exhibition. See "Art Exhibitions," The Ten American Painters," *New-York Daily Tribune,* 4 April 1899, 6: "'Morning' is a sympathetic and almost masterly interpretation of an enchanting scene, studied in an enchanting hour. The tender, palpitating light; the fragile, elusive tree forms; the rare sentiment of the theme, the inarticulate poetry of it, are all brought together in a pictorial whole that is conceived with originality and handled with sure understanding."

100. "John H. Twachtman," *New-York Daily Tribune* (9 August 1902), 8.

JOHN TWACHTMAN AND THE THERAPEUTIC LANDSCAPE

Kathleen A. Pyne

Introduction: More than an American Monet

In May of 1893 several of Twachtman's Connecticut landscapes were exhibited alongside the works of J. Alden Weir, Claude Monet, and Paul Besnard at the American Art Galleries in New York. Critics responded to the occasion as if it were, like the Fine Arts Palace at the World's Columbian Exposition in Chicago of that year, another opportunity to compare American painters with French and thus assess the nation's cultural progress at that historical moment. Rather than receiving Twachtman as an American Monet, however, contemporary viewers were struck with the differences between the visions of the Americans and the Frenchmen. If Twachtman and Weir were painting in an impressionist manner, they reasoned, the Americans were formulating an impressionism minus its violence, force, and "virile power." Looking at the American paintings was like looking at the French "through a fog which washes out the force and substance and leaves the shadow." As Twachtman fused the parts of the landscape into a tonal unity, he left the viewer to contemplate "the ghost of something else," or the "sentiment of the landscape."[1]

In this contemporary evaluation it is obviously Whistler's aestheticism that is suggested more than Monet's science of vision, and Whistler was precisely the artist these critics put forth as Twachtman's artistic predecessor. If Twachtman's landscapes of the 1890s, however, in some formal sense recall Monet's, the question of how Twachtman's art approached both the supreme empiricism of Monet and the consummate utopianism of Whistler must be addressed. But beyond purely formal considerations, it is important to inquire into whether any similarity between the intended meanings of Monet's and Twachtman's works can be apprehended, if we are to understand the place of Twachtman's painting among the impressionist and symbolist camps that made their appearances between 1890 and World War I. In order to answer these questions, we must consider Twachtman's artistic process, in which he received sensuous

cat. 1. John Twachtman, *Winter Harmony* (detail), c. 1890–1900. National Gallery of Art, Washington, Gift of the Avalon Foundation

data from nature at the same time that he projected his inner landscape onto nature, selecting and ordering what he saw. And we must look also into the origins of Twachtman's art in his thought, particularly as embodied in the dynamic between his private world and the public ideology that partly shaped that world.

In the late 1880s and early 1890s Monet and Whistler were not aesthetic antagonists, nor were they perceived as such by many American artists, for example, Twachtman's friend Theodore Robinson. At the moment when Twachtman supposedly shifted his art in the direction of impressionism, Monet had already narrowed the gulf between himself and Whistler by his own efforts. In 1887 Monet visited London and stayed with Whistler, "returning to France deeply impressed with the man and his work."[2] In the following years Monet renewed his interest in the colored atmosphere of Turner and the tonal poetry of Corot as well. Now pursuing the mystery of the changing atmospheric veil in his own work, he abandoned the fragmentation of form and the vibration of colored light that were characteristic of his high impressionist period of the 1870s. Moreover, during these years Monet drew close to Stéphane Mallarmé and his circle and introduced Whistler to the symbolist poet, who translated Whistler's "Ten O'Clock" lecture into French. In the series paintings of the 1890s Monet finally arrived at a process of heightening his observation of nature's effects and then reworking and harmonizing the pictures over the course of long studio sessions. Monet's vision by the 1890s came to incorporate the principle of "suggestion through infinite nuance" common to both Whistler and Mallarmé.[3]

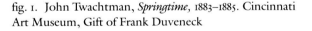

fig. 1. John Twachtman, *Springtime*, 1883–1885. Cincinnati Art Museum, Gift of Frank Duveneck

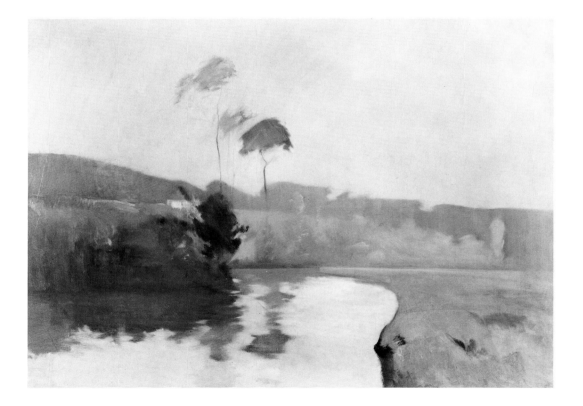

fig. 4. Claude Monet, *Branch of the Seine near Giverny (II)*, 1897. Museum of Fine Arts, Boston, Gift of Mrs. W. Scott Fitz

fig. 2. John Twachtman, *Japanese Winter Landscape*, 1879.
Philadelphia Museum of Art, Alex Simpson, Jr.
Collection

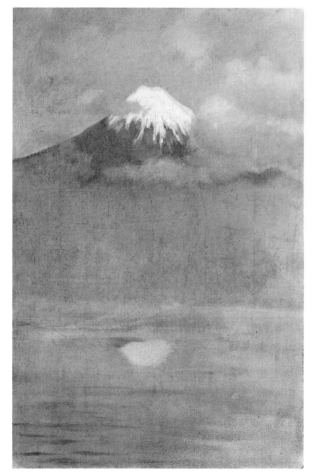

fig. 3. John Twachtman, *Fujiyama,* c. 1885. Cincinnati Art
Museum, Gift of Harold W. Nichols

While Monet moved closer to the symbolist absorption and reflection in the 1890s, Twachtman since at least the mid-1880s had already been evolving a landscape mode that evoked a state of reverie. His French landscapes, such as *Springtime* of 1883–1885 (fig. 1), show him reaching for a mood of quiet reflection, abetted by the strategies of Whistler's nocturnes and the conventions of Asian artists. *Japanese Winter Landscape* of 1879 (fig. 2), and *Fujiyama* of c. 1885 (fig. 3), for example, more blatantly exemplify the way in which Twachtman was working to internalize the abstract brushwork and simplified, flattened spaces of Asian painting and prints.[4] Twachtman's *Springtime* is an exercise in translating a felt reality into an abstracted and calligraphic form, in comparison with the more rigorously observed reality that Monet imposed upon his painted image. But *Springtime*'s melancholy tonal harmonies and landscape forms, half-revealed, half-concealed in the mists, look forward to Monet's series *Morning on the Seine* of 1896–1897 (see fig. 4).

In 1888–1889, however, Twachtman shifted from thin, even surfaces and attenuated proportions to greater surface complexity and texture and squarish proportions. His color sensibility meanwhile remained much the same. (*Springtime* and *Windmills* [1883, Charles and Emma Frye Art Museum, Seattle], for example, display a chromatic range as high in key as much of his work in the 1890s.) In *Icebound* of c. 1889 (fig. 5, cat. 2), his Whistlerian, washlike handling of paint gave way to brushwork that is more rubbed and blended and a surface more textured and complex in color. Now he allowed the cooly toned ground occasionally to show through the warm white upper layers of pigment, so that a quiet, opalescent surface emerges from the subtle modulations of hue from icy blue and white to mauve and salmon, in place of the closer, more limited tonal harmonies of the earlier works. What led him to this new direction

fig. 5. John Twachtman, *Icebound*, c. 1889. The Art Institute of Chicago, Friends of American Art Collection

in sensuous touch and elusive color still remains an open-ended question. It has been assumed that Robinson, who had been befriended by Monet at Giverny in 1888–1889, in his newly found enthusiasm for Monet's aesthetics, was instrumental in this change.[5] It seems more likely, however, that Twachtman's extensive work in pastels on colored papers of the previous year insinuated the means by which he might continue to deepen the sense of nuance and ephemeral mood he had been seeking.

Perhaps the reasons for Twachtman's push toward nuance and complexity can be located not so much in the terms of formal mannerisms that might speak of any direct one-on-one influence, but in the terms of an aesthetic philosophy, of what the painter ought to express as the beauty of nature. As recorded in his diaries, Robinson's conversations with Monet in 1892 centered on aesthetic values rather than technique. According to the diaries, the immediate present—the isolated instant suggested in his high impressionist landscapes—no longer fascinated Monet as much as the suggestion of mystery and duration. Typifying the earlier tendency is *Landscape: Parc Monceaux, Paris* of 1876 (The Metropolitan Museum of Art, New York), in which the vibration Monet observed in the atmosphere is so strong that, in his vision, form is fragmented into shards of colored light, and the flash of light at midday hints at no metaphysical realm beyond the split second of the present. By the time he was engaged in the series paintings of the early 1890s, when Robinson recorded their conversations, Monet's aestheticizing process, which he carried out in the studio, imbued nature with the sense of the mystery he discovered in the veiled atmosphere. In these late landscapes,

such as *Branch of the Seine near Giverny (II)*, the sense of time is more complex. Memory entered into Monet's act of reflection in the studio; thus, the intangible veil intimates a Bergsonian sense of duration, an interpenetration of past with present.[6] Though some close to Monet tried to claim a kind of a pantheism for these landscapes, Monet professed to be an atheist. Thus, his search for the inexpressible mystery of nature has probably more to do with the emotional force nature exerted over him than with any intended expression of spiritual correspondences in his landscapes.[7]

The Discovery of Nature at Greenwich

Twachtman's Greenwich landscapes display little of Monet's bright light of the 1870s, which suggests only a moment arrested in the immediate present. Rather, from his French landscapes of the mid-1880s to his Greenwich compositions of the 1890s, Twachtman persisted in searching out the delicate and mysterious moods of nature. His increasing articulateness on the purpose of landscape painting is preserved in the letters he wrote to his close friend, J. Alden Weir, who lived near Greenwich in Branchville, Connecticut.[8] Twachtman's condemnation of materialism in expression and technique, for example, is voiced in his discussion of Jules Bastien-Lepage, whose work he observed at close range while he was studying drawing at the Académie Julian in Paris in 1883–1885. Though Weir and other young American painters at this time much admired Bastien-Lepage, the French painter's work did not meet Twachtman's standards. Bastien-Lepage's naturalism, he maintained, was rarely poetic and seldom went beyond modern realism, which consisted "too much in the representation of things." Further, Twachtman strongly disapproved of Bastien-Lepage's fussiness, his manner of treating every small detail with equal value, which had the result, he said, of producing fatigue and restlessness in the viewer, rather than comfort. For Twachtman, then, comfort, or psychic repose, for the viewer was to be a hallowed objective in conceiving the image of the landscape.[9]

Like Robinson, Twachtman abandoned the flat, utilitarian landscape of his midwestern origins for the softer, more Arcadian countryside of New England. After he had isolated himself with his family in the farmhouse on Round Hill Road in Greenwich in 1889, Twachtman began to locate the means to securing emotional comfort from nature and art. In approaching the landscape mute and alone, he found that nature would yield its mystery. An often quoted passage from a letter Twachtman wrote to Weir on 16 December 1891 reveals the profound state of calm he obtained through his immersion in an ambience of silence, moonlight, and fog.

> To-night is full moon, a cloudy sky to make it mysterious and a fog to increase mystery. Just imagine how suggestive things are. I feel more and more contented with the isolation of country life. To be isolated is a fine thing and we are then nearer to nature. I can see now how necessary it is to live always in the country—at all seasons of the year.
>
> We must have snow and lots of it. Never is nature more lovely than when it is snowing. Everything is so quiet and the whole earth seem [sic] wrapped in a mantle. That feeling of quiet and all nature is hushed to silence.

In a letter from the following September Twachtman also praised the ''fine and rare'' gray day, when the atmosphere and foliage were more delicate and the shorter days produced more ''early morning effects.''[10] In these passages it is the transitional or marginal moment, the soundless interval between nature's more vigorous states of being, that he identifies as the means to his emotional contentment. Immersion in nature at her most elusive and refined state allowed Twachtman to escape the psychic gravity of a life that was, by his own admission, frustrating. The therapeutic encounter with nature is reenacted in the repeated structures of his Greenwich compositions; their heightened quiescence is at once Twachtman's artistic rebuke of Bastien-Lepage and his reformation of the naturalistic mode.

The structures of his winter landscapes, focused on the brook on his farm (see figs. 6 and 7) or the house, succinctly confirm Twachtman's written account of how he found comfort in the suprarefinement of nature or the work of art. *Winter Harmony* (fig. 8, cat. 1), for example, pulls the viewer into the picture space along lines of movement established by the V shape of the brook, the diagonals of the banks, and the vertical trees lining the banks. Characteristically in these landscapes, the placement of the horizon near the top of the canvas induces the eye to rest at the center of the composition in the mass of the brook. These quiet, intimate spaces enfold the viewer in the niche cut out by the brook and its banks and allow the viewer to find shelter there. The absorptive surface with its soft, pastellike texture also works to caress the eye, and the thin washes of opalescent cool and warm hues suffuse the observer in an oceanic atmosphere of mist and snow—a realm in which movement of tone and light is slow, gradual, and without incident.

Across the surface of the snow and water cool blues shift almost imperceptibly into warm mauves and back again. Twachtman's technical procedure of thinning out his oil

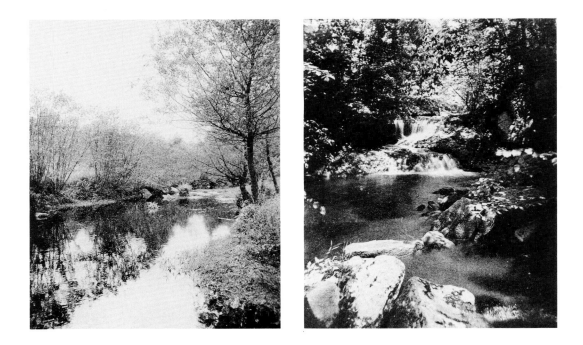

LEFT: fig. 6. Horseneck Brook, c. 1902

RIGHT: fig. 7. Horseneck Falls, c. 1902

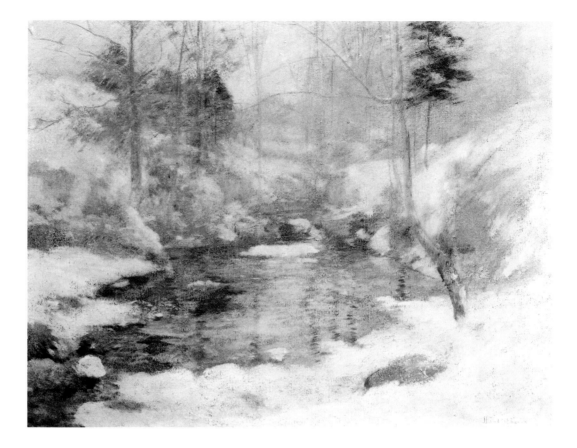

fig. 8. John Twachtman, *Winter Harmony,* c. 1890–1900. National Gallery of Art, Washington, Gift of the Avalon Foundation

pigments, layering, rubbing, and blending hues into one another, usually over a colored ground, points to a sensibility garnered from the powdery, blended effects of his pastels. Oily residues were further depleted from the surface through his process of using mastic (a resin soluable in turpentine) in place of oil and varnish and then exposing the canvas to the sun and rain. Not only did he enhance the flatness of the landscape in this process, but he also obliterated distinctions between the weighted and textured qualities of substances, distinctions that impart palpable identities to earthly objects.[11] Through this painterly strategy the corner of space defined by the brook, banks, and dematerialized trees proffers a weightless floating experience for the viewer and, metaphorically, a microcosmic encounter with the greater unifying spirit that underlies the grosser appearances of nature.

Whether the brook is revealed in a flat asymmetrical curling shape as in *Icebound*, or is nearly concealed under the blanket of snow as in *Frozen Brook* (cat. 7), it is always the source of life that animates the frozen world and the implicit focal point of the composition. If it is revealed, then its shape and contours are presented as fluid and metamorphic; if concealed, its recondite presence under the snow still intrigues. Twachtman sometimes ceded the center of the canvas to the image of the house, which then likewise dominates the field of vision. In Twachtman's personal iconography the structure of the house is often intimately bound up with nurture signified by the fam-

ily unit. (See, for example, *On the Terrace* and *The Portico* [in Peters essay, figs. 27, 28], in which the figures of the family are identified with the domestic structures with which they are juxtaposed.) In *Round Hill Road* (fig. 9, cat. 14) the house receives a treatment similar to that of the brook; it is suffused in atmosphere to the point where it is nearly dematerialized and then protected with the surrounding trees and swelling ground. As it marks for Twachtman the sacred inner precinct of the family, the house presents the allure of nurture and holds out the possibility of shelter from the frozen world around it.

Twachtman's centralized, hieratic compositions invested a structure at the center— either the house or the brook—with his emotional longing, and this preference for repetition of the pattern calls attention to the fact that he worked from a predetermined order in his mind, rather than from any spontaneous impressionist vision. His canvases prepared with colored grounds, and sometimes with a penciled-in design, again relate more to decorative, nuanced surfaces of Monet's late works, than they do to the canvases of Monet's high impressionist period, which were less deliberated over and more quickly executed.[12] Twachtman once told Weir that in his mind "Ten thousand pictures come and go every day and those are the only complete pictures painted, pictures that shall never be polluted by paint and canvas."[13] Twachtman repeatedly centered, protected, and dematerialized the domestic symbol, conferring on it a prescriptive power and revealing his own quasi-religious reverence toward the mysterious feminine other. Through their structuring Twachtman's landscapes impel the viewer into intimacy with the house or brook, and into an empathic re-creation of the artist's contentment in the asylum of nature or the home.

Twachtman's viewers responded to his winter landscapes just as he must have wished during the early 1890s, when he seems to have executed and exhibited the majority of these compositions. His work never sold better than it did in the late 1880s and early 1890s, and he was certainly accorded more exhibitions in New York in this period than at any other time in his life.[14] Since the mid-1880s the fragile atmospheres of his French landscapes had primed his New York audience to expect from him an expression of "the inexpressible."[15] Critical commentary in the early 1890s reiterates an appreciation of Twachtman's work that recalls his own evocation of nature to Weir. Twachtman's delicacy and charm, his "tender vaporousness" and invisible technique, his penchant for unity and mood, and the affinity of that mood to Asian landscape painting all made a deep impression on his contemporaries.[16]

The viewer's ability to discern the hidden life of the brook under the snow in these landscapes sharply separated those with a prosaic and materialistic turn of mind from those with the imaginative capacity to grasp the intangible essences of these landscapes.[17] One of the writers most sensitive to these hidden mysteries was John Cournos. Writing for *The Forum* in 1914, Cournos was especially struck with the kinship between Whistler, the Zen painters of Japan, and Twachtman. He determined that Twachtman's brush, like that of the Zen painters, was invisible; his brush lost itself in the "soul of things" and in the process effaced the painter's self. For Cournos, Twachtman's evasive technique evoked "a kind of artistic Nirvana, wherein the spirit

fig. 9. John Twachtman, *Round Hill Road*, c. 1890–1900. National Museum of American Art, Smithsonian Institution, Washington, Gift of William T. Evans

becomes free of matter"; his winter landscapes thus "lent serenity to the soul."[18] Charles Caffin, who wrote for a number of New York newspapers and journals in the 1890s, similarly interpreted these winter landscapes as spiritualist evocations of nature. Caffin determined that Twachtman, like Whistler, had "extracted" from the landscape "a whisper from the eternal"; the ethereality of winter in Twachtman's hands represented "the effort of an artist to get free of himself—of the material, by giving expression to the spirit that abides in matter."[19] Twachtman, then, intimated the cryptic reality of nature by means of a suitably hermetic technique.

Evolutionary Metaphors and Quiescence

A larger context for the response to these winter landscapes as affording psychological weightlessness and spiritual quiescence can be situated in the urgent contemporary program to realize a utopian culture. In both critical and popular discourse the rhetoric employed in the service of this utopianism was derived from evolutionary science. Since evolutionary theories supplied the new models of reality in the 1880s and 1890s, metaphors invoking these models filtered into every aspect of late nineteenth-century American culture, even the realm of aesthetics and art criticism. For example, in 1891 the critic for the *New York Times* wrote that Twachtman's landscapes were "not fit for the struggle of life in a contemporary exhibition gallery,"[20] clearly alluding to Darwin's image of nature as cruel and violent. But if Twachtman's vision obviously did not conform to the Darwinian order, it took its cues from another school of evolutionary thought altogether. Late nineteenth-century Americans by and large eschewed Darwin's picture of a violent and purposeless universe for the more optimistic liberal Protestant viewpoint of Herbert Spencer. Though Spencer today is regarded as a curiosity of Victorian intellectual history, in the last quarter of the nineteenth century he was greatly esteemed by the scientific and lay communities alike. Darwin, for example, dubbed the British philosopher "the great expounder . . . of Evolution." Spencer's ten-volume *System of Synthetic Philosophy* (published between the years 1862 and 1896) was premised on Lamarckian principles, in which adaptation to the environment was considered the primary mechanism of natural transmutation, rather than Darwin's process of natural selection. According to Spencer, change took place in natural organisms when the modifications in character and physiology that had been made in response to the environment were transmitted from parents to their offspring. Evolution in Spencer's philosophical scheme thus attained a peaceful and purposeful movement, whereas in Darwin's biological study change occasioned fearful mutations, ugliness, waste, and perpetual warfare.[21]

When late nineteenth-century Americans considered the human implications of these two inimical systems, Spencer's picture of slow, sure progress seemed infinitely preferable to Darwin's bleak view of a potentially terrifying future. Given Darwin's description of natural process, Americans concluded that they were alone in a cold, blind universe, bereft of any supernatural presence and indifferent to human fate. Spencer's philosophy allowed Americans to retain their pantheistic belief that the uni-

verse was unified by a force of divine psychical energy, which was concentrated in mankind.[22] Further advanced in this scheme was the hope that humankind could control its own destiny by controlling the environment. Human evolution could be directed toward the higher moralistic qualities of pacificism and altruism away from animalistic violence and competition, Spencer taught, if men and women were shaped by a refined environment of their own design.

In 1882 Spencer journeyed to New York to address the Americans who composed his most devoted audience, and he encouraged Americans to think of themselves as the creators of a new civilization that was destined to be "grander than any the world has known." Yet, at his farewell dinner at Delmonico's attended by the movers and shakers of New York's political and cultural institutions, he also warned that Americans should incorporate more rest and relaxation into their everyday lives, or they would soon be in danger of damaging their genetic material and losing their cultural predominance in the next generation.[23]

On the one hand, Spencer appealed to America's growing nationalism and was reassuring on the subject of human evolution, while on the other, he played directly to Americans' fears for their own well-being, psychological and spiritual as well as physical. In face of the challenges science had tendered to their traditional religious beliefs, Americans in the 1870s and 1880s were also forced to come to terms with the tremendous social and economic changes wrought by industrialization and mass immigration. As the transformation from a provincial, agricultural people to a more cosmopolitan and urban population progressed, it became apparent that a scourge of nervousness was to be one price of this progress. Amid an epidemic of mental depressions and nervous breakdowns, the Philadelphia physician George Beard in 1880 gave the name neurasthenia to this condition, which was seemingly endemic to upper-middle-class Anglo-Saxon Protestant Americans.[24] Writing two decades later, William James reiterated Beard's pronouncement and observed that the American character was stricken with an "absence of repose" and a "bottled lightning quality."

Early in his career at Harvard College, James was preoccupied with the workings of the subconscious mind. By the time he wrote the "Gospel of Relaxation" in the late 1890s he had turned to philosophy and was promoting an early form of psychotherapy called mind cure, or New Thought, which was addressed to problems of religious belief as much as it was to psychological ailments.[25] That mind cure was widely accepted as a legitimate substitute for orthodox Christian faith in this period, especially in the Northeast among intellectuals and scientists such as James, indicates the degree to which Protestant belief had broadened under the impact of evolutionary science and biblical criticism. A cross-cultural religion, mind cure combined general Buddhist precepts with rudimentary psychology, Berkleyan idealism, transcendentalism, Spencerian evolution, and Christianity. This quasi-religious, quasi-psychotherapeutic practice was based on a literature of small books and pamphlets that were passed among friends. As it was a personal rather than a communal undertaking, regular meditation was practiced in the privacy of the home, either on one's own or with the assistance of a professional mind curist (often a Christian Scientist). It was commonplace for Amer-

icans who sought answers in mind cure or spiritualism to support their more traditional Christian beliefs with these practices. For example, in 1892 J. Alden Weir consulted a spiritualist medium after the death of his wife, though he also continued to be a practicing Episcopalian. Among Twachtman and Weir's intimate circle, there were several who availed themselves of mind cure's reassurances. Theodore Robinson, for one, was convinced to try mind cure through his conversations with the painter William Lathrop, with one of his students, and with Mary French Weir, the wife of J. Alden Weir's brother John F. Weir. After failing in his attempts to treat himself, Robinson resorted to the services of two professional mind curists, one of which was Emilie Cady, the author of two mind-cure tracts.[26]

The practice of mind cure relaxed the hold of the the conscious mind over the self through meditation on a thought or an image. It was believed that, as the quiet of the subconscious mind asserted itself and the ego dissolved, one gained emotional release and simultaneously merged with the universal spirit of the cosmos. Here, the Buddhist or Zen-like emphasis on merging with the unconscious flux of the universe effected a rather moderated mystical experience. For a moment the Divine Mind and the individual psyche were one, and the meditator was "in tune with the infinite." In the aftermath of this everyday mystical practice, one emerged spiritually refined as well as emotionally and physically renewed.[27]

Twachtman and Late Nineteenth-Century Belief and Doubt

In its promotion of quiescence, harmony, and immateriality in the mind of the viewer, Twachtman's landscape approached mind cure's meditative experience. But beyond the realm of formal and affective affinity, it is possible to advance more persuasive arguments for the way in which his landscapes participate in a dialogue with popular religious beliefs and give these beliefs visual form. The basis for this discussion is located in Twachtman's personal exploration of Asian religion and Asian art in the 1890s.

Though Twachtman's religious background at this time still remains sketchy, a letter he wrote to Weir in 1892 strongly hints that he might have rejected orthodoxy and searched for new beliefs, a pattern that was common to Protestants in the period. Weir was executing a mural at the Chicago World's Columbian Exposition, and Twachtman attempted to brace up Weir's morale by reinforcing the importance of Weir's artistic undertaking. "Our God has our destiny in His hands . . ," Twachtman began, and several lines later ended just as gravely, telling Weir that "Your destiny lies not within your control. . . ." Yet the rest of the passage contrasts Twachtman's avowed faith in an omniscient God with his lapse from traditional Christian beliefs and worship, and then with Weir's more conventional, Episcopalian practice.[28] Growing up in a community of German immigrants in his native Cincinnati, Twachtman undoubtedly would have been given some orthodox Protestant training, which he had later found unsatisfying. It also becomes evident in this passage that he was looking for an alternative faith, in which "the real in life" was accorded an exalted status—a demand typical

of liberal Protestants. Like John La Farge, Twachtman turned to the East to explore a culture that was considered the antithesis of western rationalism, a culture in which commonplace reality could still intimate the supernatural.[29] Both in Asian religion and in Asian aesthetics Twachtman obtained reinforcement for his own antimaterialistic convictions about life and art.

By the time Twachtman was reading Max Müller's translations of the sacred books of Asia in the 1890s, Americans had been studying Asian religion and philosophy for more than two decades.[30] Through the activities of the Free Religious Association, Unitarians and second-generation Transcendentalists such as O. B. Frothingham, Lydia Maria Child, and Francis E. Abbot in the 1860s and 1870s promoted a comparative view of world religions. As they pursued Emerson's interests in establishing the basis of a pure religion and writing a universal bible, Buddhism in particular began to attract the attention of this group. In 1869 the young Transcendentalist and Unitarian minister James Freeman Clarke wrote on Buddhism as a "Protestantism of the East," while Child in 1870 argued for correspondences between Buddhism and Roman Catholicism.[31] By the time Phillips Brooks quipped that Boston preferred "to consider itself Buddhist rather than Christian" in 1883, the interest in Buddhism had spread beyond the circle of northeastern intelligentsia to the upper-middle-class population at large. Sir Edward Arnold's biography of the Buddha, *The Light of Asia* (1879), "took Bud-

BELOW LEFT: fig. 10. John Twachtman, *Winter Silence*, c. 1890–1900. Mead Art Museum, Amherst College, Gift of Clay Bartlett

BELOW: fig. 11. John Twachtman, *Hemlock Pool*, c. 1890–1900. The Addison Gallery of American Art, Phillips Academy, Andover, Massachusetts

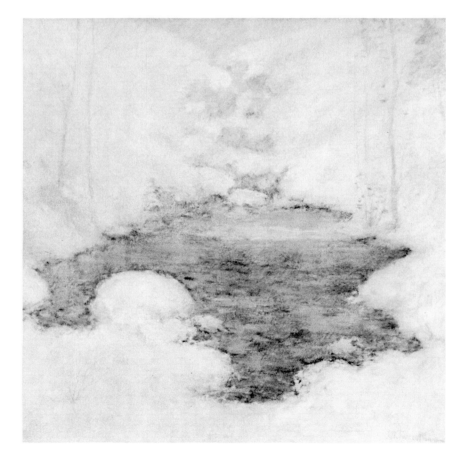

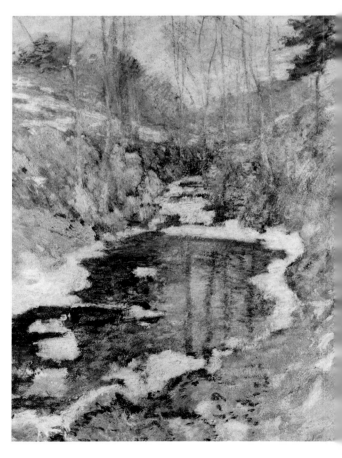

dhism out of the study and into the parlors and workshops.''[32] Arnold lectured extensively in the United States in 1889 and 1891, as did the English student of Buddhism T. W. Rhys Davids in 1894–1895. Scholars such as Davids continually protested that popularizers such as Arnold distorted the principles of Buddhism. Arnold, for example, had interpreted the idea of Nirvana as a final liberation of the spirit rather than an annihilation of the self, and other American writers after him such as Lafcadio Hearn followed suit. Both levels of discourse on the subject, however, assisted Protestant Americans in assimilating Buddhism to Christian beliefs in their quest for a broader, more universal faith. As Emerson had favorably compared the Oversoul with the Hindu concept of the Brahma, Americans now in the 1880s read Buddhism to reaffirm the idea of a spiritual energy immanent in nature; Buddhism's metaphors became immensely helpful in accomodating traditional Protestant beliefs in Providence to the new science, especially to Spencer's ideas of an unseen energy force residing in nature.[33]

Twachtman and the Mind Landscape

Twachtman's fascination with Japanese prints and ink paintings was sustained over the course of his career because their modes promised to teach him a way of picturing nature that was the opposite of what he considered bourgeois and prosaic. The prints and ink paintings embodied the Buddhist affirmation of the mysteries in the commonplace, ephemeral phenomena of nature. In late October of 1893 Twachtman was most enthusiastic over an exhibition of Japanese prints he had just seen at the Museum of Fine Arts in Boston. At this time there were also several exhibitions of Japanese prints in New York, and Robinson and Weir were busy purchasing these prints as well.[34] In terms of artistic strategies, it is obvious that in landscapes such as *Icebound* and *Winter Silence* (fig. 10, cat. 3) Twachtman sometimes employed the curling, asymmetrical abstracted shapes of *rimpa* art, while at other times in *Round Hill Road* or *Hemlock Pool* (fig. 11, cat. 5) he emulated the vaporous, flowing brushwork of Chinese Sung and Japanese Zen landscapists.[35] Disdaining the ''prosaic'' sensibility of the ''bourgeois'' masses, who favored facts over essences, Twachtman, then, labored for recognition from those with an aesthetic understanding comparable to his own—for the likes of Weir, or the collectors Charles Lang Freer or John Gellatly (though Freer unfortunately did not buy Twachtman's work until after the artist's death).[36] At this time liberal Protestants and agnostics, such as Freer, Gellatly, Whistler, and Twachtman, commonly substituted belief in a religion of art for traditional Christian belief. Thus, aesthetic sophistication was regarded as a mark of spiritual refinement. In an age of doubt about higher spiritual realities, art could be worshipped as the ''spirit enfleshed,'' just as understanding of a rarefied beauty could verify the existence of the human soul.[37] For Twachtman, appreciation of the strange beauty of his abstracted shapes and complex, shifting surfaces identified the viewer as a member of this elite order.

Just as Twachtman's dematerialized image of nature supplied viewers with a surro-

gate experience for the quiescence of nature, contemporary connoisseurs similarly discovered in Sung ink landscapes an "escape from routine being," for the shadowed spaces of ink paintings furnished an imaginative refuge in the sensuous and spiritual delights of nature.[38] Twachtman found his way to an idiosyncratic form of the Buddhist mind landscape, perhaps through perusing Buddhist philsophy at the same time that he was intuitively transforming the Zen mode of the Japanese art he studied. The self-reflexive structure and brushwork of Twachtman's images recorded his mind's motion and release, much as the calligraphic brushstrokes of the Zen painter (or the Sung painter the Zen painter emulated) bear the imprint of his mood.[39] While in the Chinese or Japanese landscape the eye is left to wander vertically up the trails of a mountainside, seeking refuge in the wooded alcoves along the way, Twachtman typically truncated this movement into a vast space by pushing the horizon line up to the top of the canvas, thereby confining the mind to the intimacy of the foreground niche defined by the brook and its banks. Instead of meandering through expanses of ground, Twachtman's sense of escape is effected in the flux of the painted atmosphere that suffuses nature and the flowing form of the brook. From this meditative immersion in nature's elusive mood there emanates an experience of weightlessness and release.

For the Buddhist, the true reality of this existence is symbolized in the transient and the amorphous elements of nature, and the concrete world, as humans experience it, is the highest reality; one only strives to understand the world, not to enter a realm beyond. But in the act of understanding, the truth of the world is apprehended as a void in which the perceiving consciousness and the perceived world are one.[40] In Buddhist literature and painting, water symbolizes this void, and in Taoism the limpid, nonresisting flow of water serves as a metaphor for the way to achieving transcendence.[41] Though the image of the body of water had been a staple in Twachtman's landscapes since the mid-1880s, in the Greenwich canvases the centralized treatment of the brook, the falls, or the pool on his property hints that for Twachtman this protean element held a deeper symbolic significance. Giving the viewer no other space to inhabit or elements to focus on, Twachtman forces his viewer into rapport with the formlessness of water and air and attempts to move him or her to slough off the body and enter into a state of weightlessness. Twachtman's projection of the amorphous shape of the brook as an entity that is both formed and formless lends these images the possibility of a generalized Zen reading, in accordance with the late nineteenth-century popularizations of Buddhism. In *Icebound*, for example, the intricately swinging contours of the brook imply a ceaseless movement, a process of becoming in which new forms are constantly born from its formlessness. Like the atmospheric veil surrounding it, the body of water in these landscapes is beyond objectification; it exemplifies a constant process of releasing its boundaries and transcending its former identity.[42] In insisting on the experience of merging with this slow, nearly imperceptible movement in nature, in yielding the boundaries of the self and entering this fluid state of being, Twachtman found comfort and security in his submergence in the universal mother.

cat. 2. John Twachtman, *Icebound* (detail), 1889–1900. The Art Institute of Chicago, Friends of American Art Collection

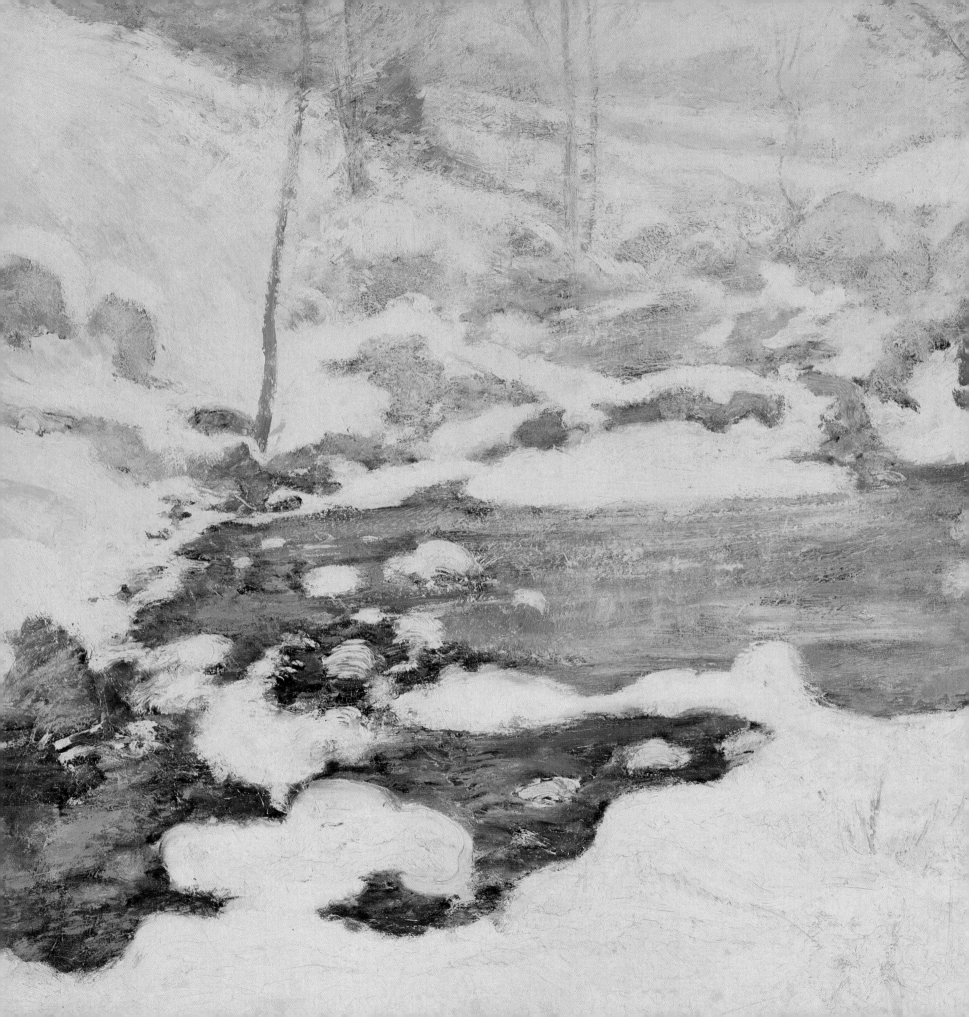

Interestingly, late nineteenth-century Americans who were also well read in this popularized form of Buddhism interpreted Twachtman's winter landscapes, not as the death of nature, but as nature in repose and on the verge of renewal. Contemporary interpretations favored readings suggesting cyclical metamorphosis rather than a void. Contemplating a canvas depicting Horseneck Falls in winter, for example, one critic determined that nature was only "inert," her soul held still "in the grip of winter," and that the scene was "an emanation of Nature's spirit, interpreted through the spiritual emotion of the artist." In terms that evoke Twachtman's vision of nature, the writer Hamilton Wright Mabie in 1896 gave voice to the liberal culture's pervasive denial of death and evil in nature. He explained that "winter is the concealment, not absence of life, and the woods are as full of potential vitality when the snow covers them as when the summer sun strives in vain to penetrate the depths of their foliage."[43] In Twachtman's canvases there is a similar understanding that the stasis of nature in winter, which is marked by a profound silence, is not death, but an intangibility of being that offers a therapeutic state of repose.

Conclusion: Twachtman and the Quest for Cosmic Comfort

Perhaps the most fascinating parallel between Twachtman's landscapes and Monet's is the way in which the French painter eventually evolved a comparable therapeutic purpose in his late works. In 1909 Monet articulated his intentions in his *nymphéas* in precisely the same terms of psychological comfort that Twachtman had been developing in his paintings since his French landscapes of the mid-1880s. As the viewer faced the "watery surface without horizon and without banks," Monet said he hoped that "nerves overstrained by work would be relaxed there, following the restful example of the still waters, and to whosoever lived there, it would offer an asylum of peaceful meditation at the center of a flowery aquarium."[44]

Surely if any American painter in this period was in need of such comfort it was Twachtman himself. Unlike Robinson, however, who had sought solace and therapy in mind cure in 1895 shortly before he died, there is no evidence that Twachtman ever availed himself of such assistance. Rather, as his repeated pictorial structures and his outpourings to Weir testify, the experience of nature and the process of making art served for him as two interrelated parts of a personal therapy. Reveling in the isolation of his farm near Greenwich, the loner Twachtman identified with the German poet Heinrich Heine, who personified the romantic genius alienated from the bourgeois masses.[45] In the early 1890s when his imagery was most dematerialized, the sales of his work had been good, but at the turn of the century, when he had turned to a more vigorous, calligraphic brushstroke and more dramatic contrasts of light and dark, he had trouble selling his new productions. In addition to these adversities, his peers at the National Academy of Design added insult to injury by rejecting his entries at the annual exhibition in 1902, the year he died.[46]

From 1889 to the time of his death Twachtman made his living by teaching at the Art Students League in New York, which entailed constant separation from his family

and commuting weekly from the idyllic Connecticut farm. After reportedly suffering from malaria in the summer of 1894, Twachtman was particularly hard-hit and guilt-stricken in 1895 by the death of his eight year old daughter Elsie of scarlet fever.[47] By 1900 his disappointment with his life was manifested in his separation from his family, his wild mood swings, and his tendency to drink heavily. While his wife accompanied their eldest son J. Alden Twachtman to Paris to study art, Twachtman remained at Gloucester and Cos Cob from 1900 to 1902.[48] In these last years, he seemed to have something "gnawing at his soul," according to his student Eliot Clark. When an editor of the *Century Magazine* commented to Twachtman that he seemed to "lead an ideal life, living in the country with your family about you, and just painting all the time," Twachtman expressed his frustration, perhaps with the artistic task he had set before himself, as much as with his attempt to build a personal utopia. "You don't know what it is to spend your life trying to do something that you can't," he replied.[49]

Twachtman's longing for reassurance in the face of overwhelming social and philosophical changes typifies the dilemma of his class in the late nineteenth century, while his response to that longing reflects the general tendency to create idealized private environments that could be controlled, instead of grappling with the unwieldly problems that plagued the public domain. At a time when Americans demanded to know they were not alone in the universe, the Greenwich landscapes in particular embodied a sense of the world as a coherent, symphonic entity that is responsive to the needs of human beings.[50] From the world he created for himself at Greenwich, Twachtman formulated the aesthetic unity of his landscapes as an answer to the psychological quest for cosmic comfort. This answer—and all others like it derived from the Spencerian and liberal Protestant vision of nature—was ultimately doomed to failure. With the advent of World War I it became tragically apparent to Americans that the reality of the larger world rested on the Darwinian model of struggle. But for a decade at least, the tenuous belief in aesthetic vision as a sign of the soul was made to substitute for the certainty of ultimate truths. The Greenwich landscapes are poignant reminders of that late nineteenth-century world of doubt and faith.

Notes

1. See "Impressionism and Impressions," *The Collector* 4 (15 May, 1893), 213–214; and the *New-York Daily Tribune* (28 May 1893), 14, cited in John Douglass Hale, *The Life and Creative Development of John H. Twachtman*, 2 vols., Ph.D. diss., Ohio State University, 1957 (Ann Arbor, 1957), microfilm, 1:91. Dorothy Weir Young, *The Life and Letters of J. Alden Weir*, ed. with an introduction by Lawrence W. Chisolm (New Haven, 1960), 188, cited the *Boston Transcript* (1896) as characterizing Weir's work as "Impressionism minus its violence." Young 1960, 178, noted that critics (unidentified) in 1893 also commented on Monet's lack of decorative sense, which they found to be pronounced in the work of Twachtman and Weir. They observed that, while Monet's sense of color was splendidly "barbaric," the subdued palette of the Americans was composed of "silvery grays modified by greens and blues quite as silvery." John Cournos, "John Twachtman," *The Forum* 52 (August 1914), 246–248, judged Twachtman to be kin to Whistler rather than Monet. Twachtman's art, he stated, is without the show of power, without the manifestation of ego, that Monet flaunts in his canvases. Charles H. Caffin, *The Story of American Painting: The Evolution of Painting in America from Colonial Times to the Present* (New York, 1907), 281–282, also affirmed that Twachtman's achievement was comparable to Whistler's.

2. John House, *Monet: Nature into Art* (New Haven and London, 1986), 222.

3. On Monet and Whistler, see House 1986, 221–225; and on Monet's Mallarméan sensibility, see Robert Goldwater, *Symbolism* (New York, 1979), 2.

4. *Fujiyama* clearly recalls Hokusai's woodblock prints of Mt. Fuji, especially the *South Wind and Clearing Weather* from the *Thirty-Six Views of Mt. Fuji*. A photograph in the files of the Whitney Museum of American Art, showing a landscape painting possibly of Niagara Falls (1879, owned by Mrs. Jacob M. Kaplan in 1960), also contains a high horizon line and abstract black brushwork characteristic of Asian ink painting. Twachtman's native city of Cincinnati would have provided him ample opportunity to view Japanese prints in the period following the Philadelphia Centennial exhibition. In the 1870s Cincinnati was the seat of considerable activity in decorative arts, largely inspired by English and Japanese objects, which culminated in the founding of the Rook-wood Pottery in 1880. Phyllis Floyd, assistant professor of art history, Michigan State University, who is currently researching the availability of Japanese art in America in the late nineteenth century, related in a conversation that Americans in the 1880s would have had access to Japanese woodcut copies of original sixteenth- and seventeenth-century Chinese ink paintings. These small illustrated portfolios were made as handbooks of composition for second- and third-rank nineteenth-century Japanese painters, and they filtered into American art circles by the 1880s. Twachtman would have also had access to Japanese prints by the late 1870s through residencies in New York, Munich, and Venice, however. The stylistic affinities of Twachtman's landscapes of the mid-1880s with Whistler's nocturnes are numerous and involve strategies of pictorial proportions and compositional simplification, as well as application of pigment and texture. His emulation of Whistler's work in this period is given indisputable support in the example of his pastel *Canal in Venice* (1884, Sotheby Parke-Bernet sale 3978).

5. Richard J. Boyle, for example, in his "Introduction," *John Henry Twachtman: A Retrospective Exhibition* [exh. cat., Cincinnati Art Museum] (Cincinnati, 1966), 8, stated that "it seems to be more than a coincidence" that Twachtman adopted a lighter palette at the moment that Robinson would have conveyed Monet's artistic philosophy to Twachtman, presumably during the winter of 1888–1889. Though Robinson emulated the broken brushwork of Monet's vibrating effects for a time in the early 1890s, it is significant that he continued to paint very thinly and tenuously in his own manner. Robinson's conversations with Monet, as recorded in Robinson's diaries, did not dwell on brushwork or touch. All four volumes of Robinson's diaries are in the Frick Art Reference Library, New York.

6. See House 1986, 223–224. The French philosopher Henri Bergson (1859–1941) established the notion of duration or lived time as opposed to spatial or measured time in his essay of 1889, "Time and Free Will: An Essay on the Data of Consciousness" ("Essay sur les données immédiates de la conscience"), in *Selections from Bergson,* ed. with an intro. by Harold A. Larrabee (New York, 1949), 38–41. Joel Isaacson, "The Painters Called Impressionists," in *The New Painting: Impressionism 1874–1886* [exh. cat., The Fine Arts Museums of San Francisco] (San Francisco, 1986),

384–386, relates Monet's activity of heightened observation to his increasing concern for the roles of memory, fantasy, and aestheticizing in his process of finishing in the studio during the 1880s and 1890s.

7. House 1986, 224–225.

8. These letters are preserved in the form of typescripts owned by Ira Spanierman, New York. I thank Richard Boyle for his kindness in providing me with copies of the typescripts.

9. See letters dated 2 January 1885 and 6 April 1885 from Twachtman in Paris to Weir.

10. See the letter of 26 September 1892 from Twachtman in Greenwich to Weir.

11. See Hale 1957, 1:213, 243, and 248, who cited Twachtman's son, J. Alden Twachtman, as relating Twachtman's use of mastic and bleaching the canvases in the sun. Eliot Clark, "The Art of John Twachtman," *International Studio* 72 (January 1921), lxxx–lxxxi, felt that in the late Gloucester canvases Twachtman essentially sacrificed "differentiation in substances and surfaces" for the overall unity of the picture.

12. In the Rouen Cathedral series, for example, Joel Isaacson, *Observation and Reflection: Claude Monet* (Oxford, 1978), 223, observed that the encrusted colors seem to be arranged according to a "predetermined general formula." On Monet's change to complex surfaces in his late works, see also House 1986, 96–100; and Robert Herbert, "Method and Meaning in Monet," *Art in America* 67 (September 1979), 97–98.

13. Letter of 5 September 1880 from Twachtman in Cincinnati to Weir.

14. For newspaper reviews of Twachtman's works during this period, see Hale 1957, 1:64–72 and 86–91, who also states that all forty-two of Twachtman's paintings at his exhibition with Weir at Ortgies in February of 1889 were auctioned off for good prices and that this was the high point of his public acclaim.

15. One New York critic, possibly Clarence Cook, wrote that his landscapes evoked "a trooping-ground for fairies," and represented attempts to "express the inexpressible." See *The Studio* n.s., 43 (15 May 1886), 271.

16. See his exhibition reviews for the early 1890s, for example, "The Fine Arts: Oil-Paintings and Pastels by Mr. Twachtman," *The Critic* 18 (14 March 1891), 146–147; "The National Academy Exhibition; First Notice," *The Art Amateur* 26 (May 1892), 141; "Impressionism and Impressions," *The Collector* 4 (15 May 1893), 213; *New York Times,* 12 April 1891, 12, and 9 March 1891, 4.

17. Carolyn C. Mase, "John H. Twachtman," *The International Studio* 72 (January 1921), lxxiv. Mase was one of Twachtman's students at Cos Cob during the last winter of his life.

18. Cournos 1914, 245–248.

19. Caffin 1907, 281–282. Caffin also wrote for the *New York Evening Post*, the *New York Sun, Harper's Weekly,* and *The Century Magazine* among others.

20. See the *New York Times* review of 12 April 1891, 12.

21. On the American embrace of Spencerian evolution over Darwinian and the ramifications of these theories, see James R. Moore, *The Post-Darwinian Controversies: A Study of the Protestant Struggle to Come to Terms with Darwin in Great Britain and America 1870–1900* (Cambridge, England, 1979), especially chapters 6, 7, and 10.

22. See Moore 1979, 167–168 and 220–241.

23. Spencer was surely alluding here to the masses of non-Anglo-Saxon-Protestant immigrants from the south and east of Europe that had been flocking to New York for over a decade, specifically in reference to the growing social unrest which, it was believed, was fueled by this "anarchist" foreign element. For Spencer's address to the Americans and the list of attendees at this occasion, which included Daniel Huntington and John Quincy Adams Ward, see Edward Livingston Youmans, *Herbert Spencer on the Americans and the Americans on Herbert Spencer: Being a Full Report of His Interview and of the Proceedings of the Farewell Banquet of November 9, 1882* (1882; reprinted, New York, 1887).

24. See George M. Beard, *A Practical Treatise on Nervous Exhaustion (Neurasthenia), Its Symptoms, Nature, and Sequence, Treatment* (New York, 1880) and *American Nervousness, Its Causes and Consequences* (New York, 1881).

25. See William James, "The Gospel of Relaxation," *Scribner's Monthly* 25 (April 1899), 499–507; and *The Varieties of Religious Experience, a Study in Human Nature* (New York, 1961). According to Gay Wilson Allen, *William James: A Biography* (New York, 1967), 287, 368, and 469, James himself went through mind-cure therapy at least three times in his life.

26. See Robinson's diaries, vol. 1, for 5/9/92. On mind cure, see James 1961, 91–92; and Gail Thain Parker, *Mind Cure in New England from the Civil War to World War I* (Hanover, New Hampshire, 1973). On liberal Protestantism, see William R. Hutchison, *The Modernist Impulse in American*

Protestantism (Cambridge, Mass., 1976). Ralph Waldo Trine's *In Tune with the Infinite; or Fullness of Peace, Power, and Plenty* (New York, 1897) was one of the most popular mind-cure texts of the period. It was probably the painter William L. Lathrop who gave Prentice Mulford's *Our Forces and How to Use Them* (New York, c. 1889–1891) to Robinson to study in March of 1893. Robinson had first tried practicing on his own. H. Emilie Cady wrote *Finding the Christ in Ourselves* (Kansas City, 1894) and *Lessons in Truth: A Course of Twelve Lessons in Practical Christianity* (Kansas City, 1908). Robinson went to Cady in February of 1895 and then more regularly to a Mrs. Montgomery, beginning in late November of 1895 in New York City. See Robinson's diaries, vol. 1, 4/19/92; vol. 3, 1/13/95, 2/20/95, and 4/25/95.

27. See Parker 1973, 1–10 and 35–39; and James 1961, 86–109.

28. The letter of 29 September 1892 to Weir in Chicago reads: ''Our God has our destiny in His hands and the task for the noblest souls has always been the hardest. I am a firm believer in martyrs and if I better knew the life of Christ I might be a devoted churchman. We are direct opposites in our outward practices but it does not prevent us from knowing each other. That which is to me the most precious part of you is your devotion for the real in life. Your destiny lies not within your control and your courage must not fail you.'' Weir belonged to the Episcopalian Church of the Ascension in New York and would himself sometimes read the Bible to his family on Sundays. See Theodore Robinson's diary, vol. 1, 2(?)/11/93 and 11/30/93.

29. See John La Farge, *An Artist's Letters from Japan* (New York, 1897), 170 and 173. On his trip to Japan in 1886 La Farge recorded his sensation that the Japanese atmosphere was not ''inimical, as ours is, to what we call the miraculous.'' Rather, he found that in Japan he could ''fall into moods of thought . . . or feeling—in which the edges of all things blend, and man and the outside world pass into each other.''

30. Alfred Henry Goodwin, ''An Artist's Unspoiled Country Home,'' *Country Life in America* 8 (October 1905), 628, observed the Müller set of ''Far East Bibles'' in Twachtman's ''saddle room'' or den a few years after his death in 1902. On the American interest in Far Eastern religion in the nineteenth century, see Carl T. Jackson, *The Oriental Religions and American Thought, Nineteenth-Century Explorations* (Westport, Connecticut, 1981). Müller's translations of the Vedas, the Upanishads, the Buddhist Mahâyâna texts, and Japanese Buddhist texts were published in English in several editions from 1869 over the next three decades. The set Twachtman owned might well have been a four- or five-volume edition of Müller's *Chips from a German Workshop*, which was published many times by Scribner's in New York from 1868 throughout the 1880s and 1890s. These volumes contained Müller's essays on the ''science of religion,'' the Vedas, ''Christ and other Masters,'' Buddhism, Nirvana, Confucism, ''Semitic Monotheism,'' comparative mythology, Shakespeare, and the ''science of language,'' among others.

31. Jackson 1981, 103–116 and 142; see James Freeman Clarke, ''Buddhism; or Protestantism of the East,'' *Atlantic Monthly* 23 (June 1869), 713–728; and Lydia M. Child, ''Resemblances Between the Buddhist and the Roman Catholic Religions,'' *Atlantic Monthly* 26 (December 1870), 660–665.

32. Jackson 1981, 141–145 and 152. Brooks' remark was made to Mrs. Arthur Brooks in a letter of 30 January 1883, which he wrote during his sojourn in India, and is quoted in Jackson 1981, 141.

33. Jackson 1981, 151–153 and 235.

34. Since the Museum of Fine Arts, Boston, has no record of any special exhibition of Japanese prints in October of 1893, it seems likely that Twachtman saw a display of the permanent collection there, installed by Ernest Fenollosa, who was the curator of the Japanese department at Boston at that time. See Robinson's diary, vol. 2, 10/31/93. On 10 December 1893, Robinson reported that his discussions with Twachtman on Japanese art continued, and that at this same time Weir was also ''Japanese-mad'' and was purchasing Japanese prints (as was Robinson). See vol. 2, 11/30/93, 1/6/94, and 2/11/94. An exhibition of Japanese prints was held in February 1894 at Boussod-Valadon; in March 1894 the American Art Association displayed prints owned by Samuel Bing. This exhibition was probably the same as ''Japanese Engravings: Old Prints in Color Collected by S. Bing of Paris,'' which was exhibited at the Musem of Fine Arts, Boston, in April 1894. On 8 April 1894, Robinson reported that he had been to dinner at Weir's where a dealer, Heromichi Shugio, explained ''certain things about Japanese prints and books.''

35. Young 1960, 179, related that Weir was also experimenting with Japanese ink painting and

Japanese papers in this period.

36. Carolyn Mase, who studied with Twachtman during his last winter at Cos Cob, wrote that Twachtman venerated nature in her "aristocratic moods . . . when she was high above the comprehension of the masses" and that he "hated a bourgeois conception and handling of her beauty." See Mase 1921, lxxii. In relation to their conversation about Japanese prints, just after Twachtman had viewed the prints on display at the Museum of Fine Arts, Robinson also noted Twachtman's dislike of the prosaic and the bourgeois.

37. On the rise of the religion of art within the domain of late nineteenth-century liberal Protestantism, see James Turner, *Without God, Without Creed: The Origins of Unbelief in America* (Baltimore, 1985), 251–254.

38. See Laurence Binyon, *Painting in the Far East: An Introduction to the History of Pictorial Art in Asia Especially China and Japan* (London, 1913), 138–139.

39. On the mind landscape of the Chinese painter, see Wen C. Fong, "Images of the Mind," in Wen C. Fong and Alfreda Murck, Shou-chien Shih, Pao-chen Ch'en, and Jan Stuart, *Images of the Mind: Selections from the Edward L. Elliott Family and John B. Elliott Collections of Chinese Calligraphy and Painting at The Art Museum, Princeton University* (Princeton, N. J., 1984), 3–4.

40. Robert K. Heinemann, "This World and the Other Power: Contrasting Paths to Deliverance in Japan," in Heinz Bechert and Richard Gombrich, eds., *The World of Buddhism: Buddhist Monks and Nuns in Society and Culture* (London, 1984), 220, recounted the basic principles of Japanese Tendai and Shingon sects in the above terms. While Americans found divine influx or spiritual correspondences to be suggested in these intangible essences of reality, they almost universally rejected or ignored the nihilistic Buddhist interpretation of the void. See Jackson 1981, 3–59, on Emerson's study of Asian religions. Jackson 1981, 56, stated that Emerson preferred Hinduism to Buddhism and remained largely uninformed about Buddhism, whereas Americans after the Civil War avidly pursued the study of Buddhism. On the Chinese painter's method and philosophy, see Fong 1984, 4–8.

41. On Zen aesthetics and Japanese Buddhist philosophy see Shin'ichi Hisamatsu, *Zen and the Fine Arts,* trans. Gishin Tokiwa (1971; Tokyo,

1982), 51–52; and Sylvan Barnet and William Burto, *Zen Ink Paintings* (Great Japanese Art) (Tokyo, 1982), 24 and 44.

42. These concepts are drawn from the discussion of Zen aesthetics in Hisamatsu 1982, 51–52.

43. See Cournos 1914, 247, who quoted the unidentified critic. See also Hamilton Wright Mabie, *Essays on Nature and Culture* (New York, 1896), 142–144. J. Alden Weir, in a letter of 3 January 1892 to Twachtman's son, J. Alden, discussed a poem titled "The Brook," which young Alden had written about Horse Neck Brook. Weir suggested a more traditional literary meaning for the brook and connected this motif with "a greater stream which this little one will teach you much about—the stream of life. . . ." See Young 1960, 176–177.

44. Roger Marx, "Les 'Nymphéas' de Claude Monet," *Gazette des Beaux-Arts* 1 (June 1909), 529, quoted Monet as follows: ". . . l'illusion d'un tout sans fin, d'une onde sans horizon et sans rivage; les nerfs surmenés par le travail se seraient détendus là, selon l'exemple reposant de ces eaux stagnantes, et, à qui l'eût habitée, cette pièce aurait offert l'asile d'une méditation paisible au centre d'un aquarium fleuri."

45. See Mase 1921, lxxii, on his reverence for Heine.

46. See Hale 1957, 1:127 and 132, who stated that Twachtman's sales were poor after 1891, even though he was awarded major prizes at the Society of American Artists in 1888 and the Pennsylvania Academy of the Fine Arts in 1893. Mase 1921, lxxv, recounted that Twachtman said he exhibited eighty-five paintings in 1902 and failed to sell even one. Allen Tucker, *John H. Twachtman* (New York, 1931), 10–11, related that J. Alden Weir had told him of the Academy's rejection of Twachtman's paintings in 1902.

47. See Robinson's diary, vol. 3, for 11/16/94, 1/2/95, 1/14/95, and 1/15/95.

48. On Twachtman's family and personality problems, see Mase 1921, lxxiv; Clark 1921, 10–12; and Hale 1957, 1:99, 118–128, 131–139, and 128, n. 2.

49. Twachtman spent the summers of 1900, 1901, and 1902 in Gloucester and the winter of 1901–1902 in Cos Cob. See Clark 1921, 28 and 58; and Tucker 1931, 8.

50. On the longing of late nineteenth-century Americans for a symphonic universe, see D. H. Meyer, "American Intellectuals and the Victorian Crisis of Faith," *American Quarterly* 27 (December 1975), 584–603.

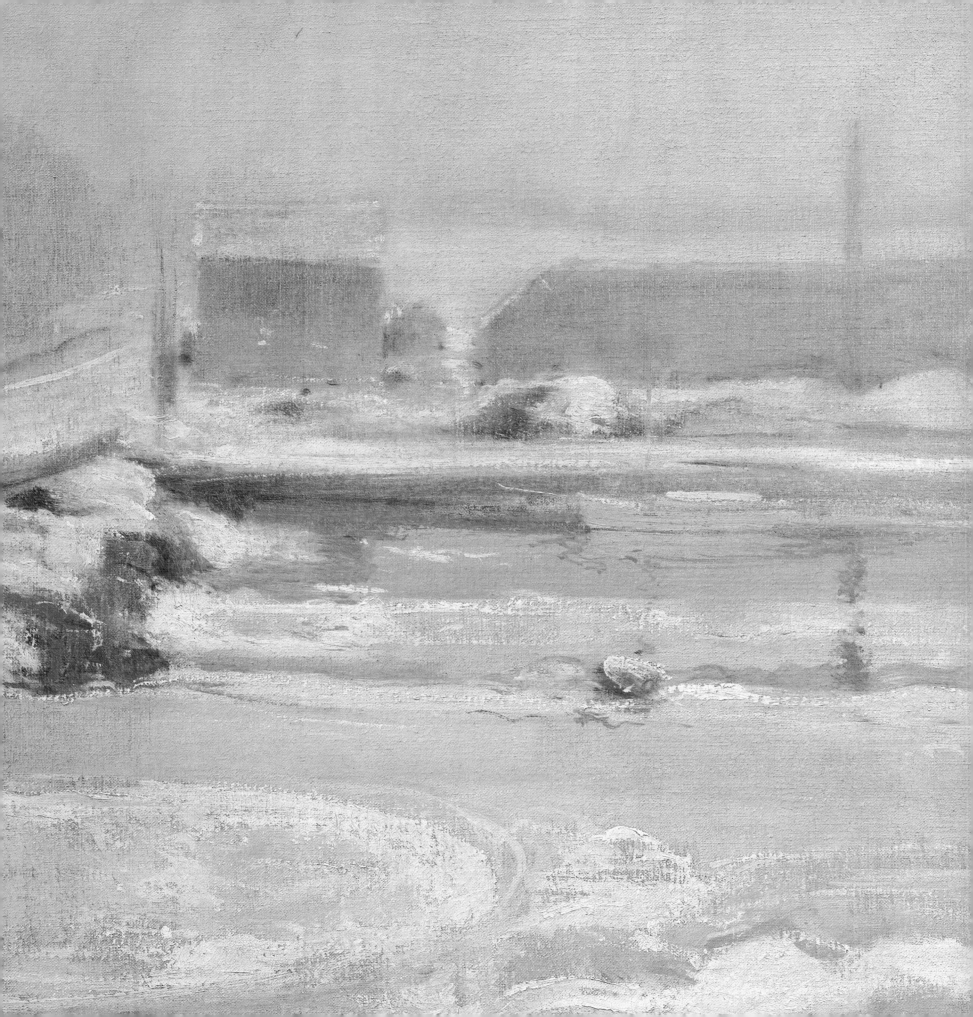

TWACHTMAN AND THE AMERICAN WINTER LANDSCAPE

Deborah Chotner

We must have snow and lots of it. Never is nature more lovely than when it is snowing. Everything is so quiet and the whole earth seems wrapped in a mantle. . . . All nature is hushed to silence. . . .[1]

John Twachtman's oft-quoted letter bespeaks the artist's unmistakable affinity for the winter landscape. His singular ability to capture the evanescent beauty of these scenes is discussed again and again by his critics and biographers. Although Twachtman painted in all times of year with sensitivity and skill, the majority of his images are winter scenes. His extraordinary accomplishment as perhaps the preeminent American painter of this season, and his place in that context, deserve attention.

Few of the giants of nineteenth-century American landscape painting devoted much energy to depicting their favorite scenery in winter. During the coldest part of the year these well-established artists worked in their studios composing and completing works based on sketches made in warmer months. Jasper Cropsey painted a few modest snow scenes, but it was the fiery red and gold palette of the American autumn that he preferred and by which he made his reputation. Asher B. Durand's countless depictions of pastures and woodlands were uniformly verdant. Frederic Edwin Church produced but two small oil sketches of winter, one of Niagara and one of the view from Olana covered in snow. When he embraced a wintry subject with ambition, he chose the awesome icebergs of the Arctic rather than the hills of New England. Church's otherworldly images of the Far North had less to do with seasonal meteorology than with nearly timeless geology. His fantastically colored masses of ice were compared to gems, their imposing size and structure likened to great cathedrals.[2] The makers of the monumental images that form the cornerstone of American landscape painting must have felt that a mantle of white covering a rocky outcropping or barren trees diminished the sense of grandeur and expansiveness of their works. However, there were a few American artists who achieved a good deal of recognition by specializing in snow scenes. Most used the winter landscape as a backdrop for the activities of its human inhabitants.[3]

cat. 26. John Twachtman, *View from the Holley House, Winter* (detail), c. 1901. Spanierman Gallery, New York

fig. 1. Francis Guy, *Winter Scene in Brooklyn*, c. 1817–1820. Brooklyn Museum, Gift of the Brooklyn Museum of Arts and Sciences

One of the earliest painters of the American landscape, British-born Francis Guy (1760–1820), recorded *Winter Scene in Brooklyn* (fig. 1), a fascinating account of what was then a busy village. Beneath a cloudy gray sky, neighbors converse on snowy corners, feed chickens in the alley, cut wood, carry bundles of kindling, or push a cart loaded with supplies. One takes a spill on the icy road. Dogs, horses, pigs, and cattle add to the sense of urgent activity in an image reminiscent of the work of Pieter Bruegel.[4]

The similarity of nineteenth-century American winter images to Northern European examples is readily apparent. Like Dutch artists of two centuries earlier, American painters such as Thomas Birch (1779–1851) and Alvan Fisher (1792–1863) placed active figures in brown and white stagelike settings under gray skies.[5] Many American artists depicted skaters on frozen lakes and rivers. Two French-born painters, Joseph Morviller (?–1868) and Regis Gignoux (1816–1882), made specialties of such subjects, Morviller working near Boston and Gignoux in New York City. By and large, these Americans drew from the Flemish and Netherlandish traditions a sense of playful well-being rather than the melancholy aspects of outdoor life in what can be Nature's most desolate season. A parallel to these European sensibilities in painting was echoed in verse by the American poet John Greenleaf Whittier in his classic reminiscence *Snow-Bound*:

fig. 2. George H. Durrie, *Winter Landscape,* 1859. Yale
University Art Gallery, Mabel Brady Garvan Collection

Yet, haply in some lull of life,
Some Trace of God which breaks its strife,
The worldling's eyes shall gather dew,
 Dreaming in throngful city ways
Of winter joys his boyhood knew;
And dear and early friends—the few
Who yet remain—shall pause to view
 These Flemish pictures of old days.[6]

The nostalgia for country life in winter is exemplified in the work of George H.
Durrie (1820–1863), the most prolific nineteenth-century painter of such scenes. He
painted in the New Haven, Connecticut, area, and may have produced more than five
hundred landscapes. A large percentage of Durrie's paintings were winter views.[7] In an
1857 advertisement for a sale of his works, Durrie specifically offered "a number of
choice Winter Scenes" and added that "no collection of pictures is complete without
one or more."[8] Durrie's works are straightforward views of picturesque, rural New
England in a season both lovely and benign (fig. 2). Sturdy, neat houses and barns and
slightly more elaborate roadside inns promise comfort and warmth. Industrious
farmers cut and haul wood or, with their families, ride securely in sleighs down snow-
covered roads. This activity generally takes place beneath gray skies, which impart to
the scene a restful rather than somber quality. The spare beauty of the New England

countryside in winter, with its gentle, rolling, purple-gray hills and the lacy patterns of leafless trees against the sky, had a special romantic appeal to the inhabitants of the increasingly urbanized northeastern United States. Durrie's particular talent in composing scenes of hospitality and prosperity made his works ideal for translation into popular imagery. Between 1861 and 1867 Currier and Ives published ten lithographs after his paintings.[9]

In 1843, almost twenty years before these prints were circulated, Henry David Thoreau made observations remarkably like those of Durrie: "Though winter is represented in the almanac as an old man, facing the wind and sleet, and drawing his cloak about him, we rather think of him as a merry wood-chopper, and warm-blooded youth, as blithe as summer."[10] Thoreau's essay "A Winter Walk" is a combination of scientific and aesthetic musings that provided a model for a number of similar essays later in the century.[11] He recorded not only the obviously beautiful and deeply affecting aspects of the season, but also the minutiae of various flora and fauna, such as the tracks of mice in the snow. Twachtman's winter images have been compared to Thoreau's. When, in his 1903 memorial appreciation of the artist, Thomas Dewing likened Twachtman to Thoreau, it was not because Twachtman and the essayist shared a similar interest in detail. Rather it was that "they were both original observers, observers at first hand."[12] Their kinship lay in the receptivity and openness of their spirit, which made one, as Childe Hassam observed, a "pleinairist in words," the other one in paint.[13]

In the decades following Durrie's success, seasonal paintings of skaters and wood-choppers appear occasionally, but there was little work concentrating on the winter landscape until almost the last decade of the century. Only one artist, John La Farge, seems to have eschewed the genre-oriented winter subject in favor of images of pure landscape before that time. His small panels, painted around 1865 to 1870, are an interesting precedent to Twachtman's, although unlikely to have been a direct influence on them. La Farge's few studies from nature are startling in their simplicity, usually consisting only of one or more trees surrounded by snow.[14] They are exquisitely fresh observations, in muted colors and with delicate atmospheric effects such as would occupy Twachtman two decades later (fig. 3).

There is no evidence that the younger artist had any knowledge of these modest studies. But the two shared the desire to capture the true appearance of the landscape by painting outdoors. La Farge described his images as having been painted "at a blow," whereas Twachtman labored a good while on each of his canvases. It is also known, however, that he painted outdoors in all seasons.[15] One of his students remembered that Twachtman, after having requested breakfast one morning when he was staying at the Holley House in Cos Cob, ". . . sauntered towards the window and stood silent there for a few moments. Turning he said, 'But Nature is fine this morning,' and went out of the room. The maid brought his breakfast and set it down. It grew cold, and somebody went to find Mr. Twachtman. They found him standing outside in the snow, painting like mad, utterly forgetful of the breakfast, ordered but never eaten."[16]

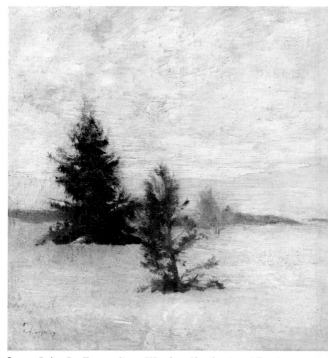

fig. 3. John La Farge, *Snow Weather, Sketch,* 1869. The Art Museum, Princeton University, Gift of Frank Jewett Mather, Jr.

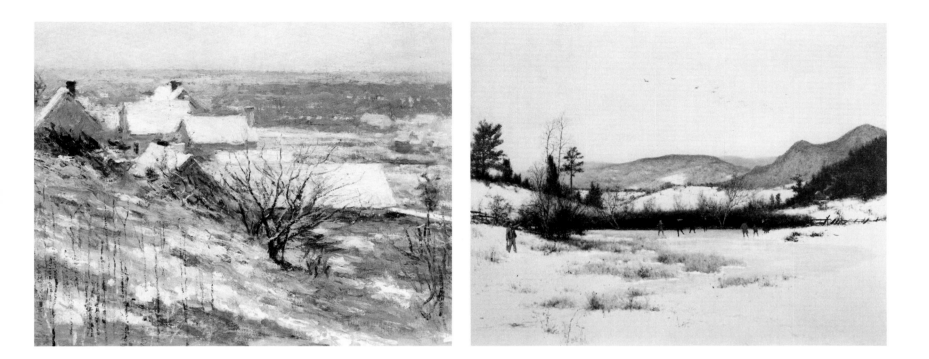

Painting snow in the open was by no means a universally accepted practice. In
these efforts Twachtman was perhaps most closely allied with Claude Monet who reg-
ularly painted outside in all weather, despite the attendant discomfort.[17] Other French
and even some American impressionists, such as Theodore Robinson (fig. 4), pro-
duced an occasional plein-air winter scene, but it was more typical for these subjects to
be produced in the studio, based on recollection.[18] Even such an artist as Jervis McEn-
tee, whose winter pieces were found "remarkable for the excellent atmospheric effect
and impression," created them in a studio in New York City from memory (fig. 5).[19]

The benefits of direct observation versus the impediments of cold weather were
discussed in the *Art Amateur* in 1901. That author promoted compromise, advocating
painting indoors to approximate the light in which the work would eventually be dis-
played, but suggesting that the landscape be observed through a window over the
course of time, since "there are the changes of morning, noon and evening; the differ-
ent effects of weather, rain, snow, hoar-frost, thaw, in each of which the scene
presents new aspects, awakens new sentiments."[20]

The emotions evoked by the winter landscape evolved throughout the nineteenth
century. Beginning with the simple delight in surroundings and pleasure in surviving
the season well as reflected by Durrie, the responses became more complex in the later
years. By the 1880s and 1890s winter was perceived to foster such beneficial aspects of
solitude as reflection and meditation. However, Winslow Homer's interpretation was
of a season less benign. The few winter scenes he created date from late in his life and
share a sense of pessimism. *Winter Coast* (1890, Philadelphia Museum of Art) depicts a
lone figure holding a gun and the goose he has shot. He is planted steadfastly on a

fig. 6. Winslow Homer, *The Fox Hunt,* 1893. The Pennsylvania Academy of the Fine Arts, Philadelphia, Joseph E. Temple Fund

cold, rocky ledge, gazing at the furious, unforgiving surf. Similarly *Sleigh Ride* (c. 1893, Sterling and Francine Clark Art Institute, Williamstown, Massachusetts) shows, rather than Durrie's vision of happy riders frolicking in the clean air, the cropped portions of two figures and their vehicle descending the hillside into the quickly encroaching darkness. But the image laden with the most foreboding is *The Fox Hunt* (fig. 6) in which the winter means not only a struggle, but ultimate death for one unfortunate creature who confronts it. So reflective is this work of the artist's troubled state of mind that his signature, like the fox, sinks into the snow.

Apart from Homer's work, there appears to be a difference in the perceptions of winter per se and of snow. While the former signified everything from quiet repose and the potential for rebirth to hardship and even death, the latter was almost always an emblem of virtue. At mid-century, in a poem replete with Victorian sentiment, James Russell Lowell wrote of snow in terms of redemption as opposed to death. Lowell's rich imagery in the poignant *The First Snow-fall*, first published around 1849, likens the fallen snow variously to ermine, pearl, Carrara marble, and swansdown.[21] He watches the snow blanket the view outside his window, and also visualizes it covering the grave of his daughter "in sweet Auburn," acting as a gift of divine grace. Lowell's poem was most certainly autobiographical, for his first daughter, a baby who died in March 1847, was named Blanche.

Thoreau dealt with the similar theme of winter as an agent of purification. He described the "decayed stump and moss grown stone and rail, and the dead leaves of autumn . . . concealed by a clean napkin of snow,"[22] and "the pure elastic heaven over all, as if the impurities of the summer sky, refined and shrunk by the chaste winter's cold, had been winnowed from the heavens upon the earth."[23]

Sixty years later, a snowfall was again seen to "shut out all ugliness, smooth. . . all

rough places, soften. . . all harsh angles. The most material mind can hardly help being soothed and rested by it, and the contemplative spirit sees earth, for once, sweet, pure, and millennial."[24]

This text was illustrated with self-consciously artistic photographs by Rudolf Eickemeyer, Jr., that share—perhaps unwittingly—many of the compositional devices, some perhaps derived from Japanese art, of the work of Twachtman. Most striking are the high horizon and emphasis on a sweeping foreground. The vastness of the area of snow in the foreground, occasionally broken by a meandering stream in both Twachtman's and Eickemeyer's works, assumes a weighty presence in the composition as a whole. The nearly unbroken expanse asserts itself both as a two-dimensional shape defined by a graceful contour and as an inviting recession into the space of the scene. The tension between the two ways of reading these snowy foregrounds is an insistent reminder that the landscape has been more than recorded. It has been interpreted according to the artist's design (figs. 7, 8 [cat. 7]).

Eickemeyer, who eventually fell into relative obscurity after a falling-out with his colleague Alfred Stieglitz, was well known in his day for both genre and landscape photographs.[25] Winter subjects became his special province. In 1894 he won a gold medal at the Society of Amateur Photographers of New York for *Sweet Home*, an image of a snow-covered field in moonlight that brought him world-wide recognition.

BELOW: fig. 7. Rudolf Eickemeyer, Jr., *Winter,* 1903

BELOW RIGHT: fig. 8. John Twachtman, *Frozen Brook,* c. 1893. Mr. and Mrs. Ralph Spencer

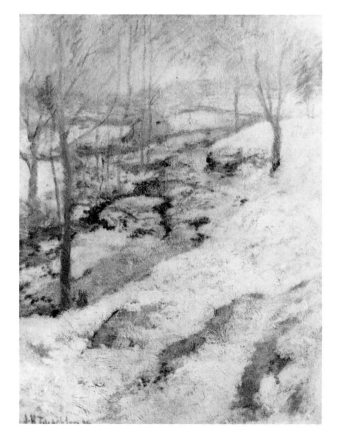

Among his subsequent projects was the illustration of a 1901 article, "A Winter Ramble," by critic Sadakichi Hartmann, which grew into the book *Winter,* in which Eickemeyer's untitled photographs alternate with quotations on the season from various writers and poets. Although these landscapes are more crisply detailed than Twachtman's and none share his square or nearly square format, they are similarly understated and meditative views. Part of this relationship may derive from Eickemeyer's ability to express "the poetical side, the painter-like qualities of Nature,"[26] and part demonstrates the changing attitude toward landscape shared by the artist and the photographer, as well as others at the turn of the century. When Hartmann, describing stems and stalks outlined against the snow, declared that "we realize that these simpler expressions of Nature are not less beautiful than her more lavish ones," he was reflecting an increasing appreciation for the more subtle and intimate aspects of the natural world. In *Nature for Its Own Sake,* the widely read critic and professor John C. Van Dyke praised the beauty of the mountain brook while referring to Niagara Falls, once the ne plus ultra of American landscape subjects, as "merely a great horror of nature."[27]

Many of Van Dyke's observations have an uncanny resemblance to certain paintings by Twachtman. The verbal equivalent of the artist's tender evocation, *End of Winter* (fig. 9, cat. 8), is found, for instance, in the author's description of the early days of March:

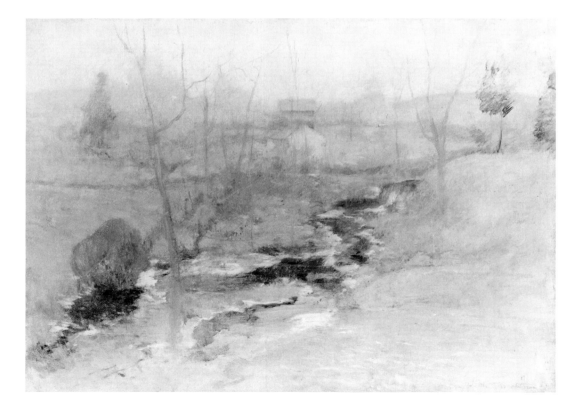

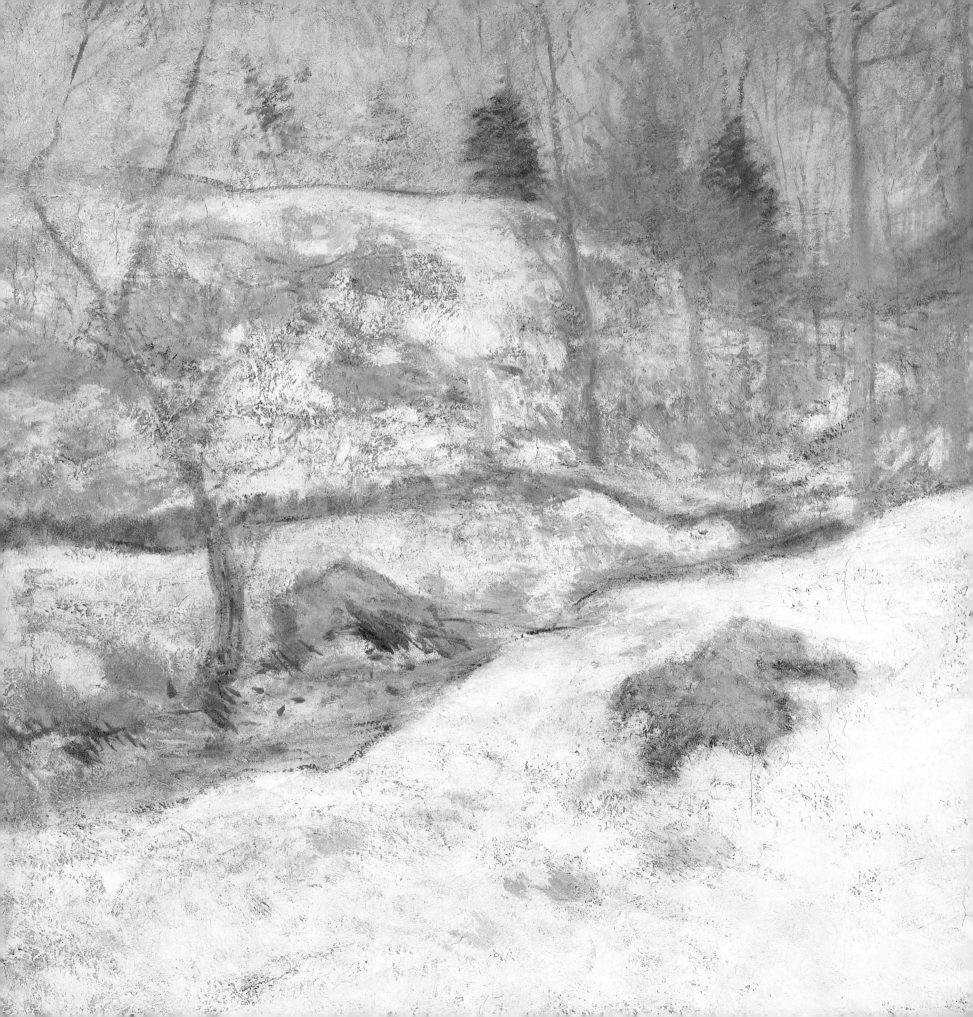

Most people declare the country "stupid" at this time and house themselves in cities if they can; but to some nature-lovers it is perhaps the most interesting season of all. The snow on the side-hill lingers; but the meadows are bare, the brooks are swollen. . . . The skeleton of nature is pushing through its winter mantle at every point; but if we look at it with appreciative eyes we shall find the hills and rocks and the bare tree beautiful as outlines merely—beautiful in their rugged, broken angles and their traceries of line against the snow or sky.[28]

All of this Twachtman conveyed with a method that is suggestive rather than descriptive. Much of his brilliance lay in his ability to convey the essence of a particular time, place, and season and simultaneously create a surface on each canvas that has an extraordinary life of its own. Whether it is the judicious use of exposed, colored ground, like the warm yellow ocher of *End of Winter*, or the delicate bleeding of color into white and the curious, heavily-textured underpaint found in *February* (cat. 11), the artist's process and the act of painting are continuously revealed. He distilled the sense of season and mood without being illusionistic.

This is in stark contrast to one of the most commercially successful painters of the period, Twachtman's contemporary Walter Launt Palmer (1854–1932). Palmer's substantial reputation was made with two subjects, views of Venice and winter scenes. The latter became his specialty after he won the Hallgarten prize at the National Academy of Design in 1887 for a painting called *January*. He was praised for his delicate use of color and he was known as one of the first Americans to paint colored shadows. Yet, critics noted the unadventurous quality of his endeavors: "The pictures of Mr. Palmer . . . are far more conventional than that of Mr. Twachtman, both in their choice of subject and their treatment of it, but [Palmer has] known how to tame the Academic formulas to the service of poetry."[29] Others found less poetry in Palmer's works (fig. 10), which were made from memory with the aid of photographs. The American impressionist Theodore Robinson, who himself was no stranger to the use of photography in painting, pronounced a collection of Palmer's work "poor and inartistic. Some of the winter things must have been wonderful, but they have no impression, no reality—are evidently painted from photos and inadequate observation."[30]

That Robinson could criticize Palmer's photographically explicit paintings as having "no reality" is telling, since he is saying not that the paintings lack the appearance of reality, but that they do not translate the artist's vision of the landscape in any vivid, personal way. By contrast, Clarence Cook, reviewing an 1891 exhibition of Twachtman's work, wrote that "like all true poetry it is the outcome of intuition rather than what is called study." He went on to say that the artist's winter pieces had "not been surpassed in truth or beauty by anyone," and in the same paragraph noted that compared to the winter scenes by Palmer, "so much admired by the public," Twachtman's work "strikes for some of us a deeper, tenderer note."[31]

There appears to be no direct precedent for the mixture of psychological reflection, fidelity to nature, and aesthetic audacity that characterizes Twachtman's winter scenes. The French impressionists were responsible, in a general way, for the nineteenth-century interest in exploring the landscape under varying conditions of light and

fig. 10. Walter Launt Palmer, *The Golden Hour*, 1907. Museum of Fine Arts, Springfield, Massachusetts

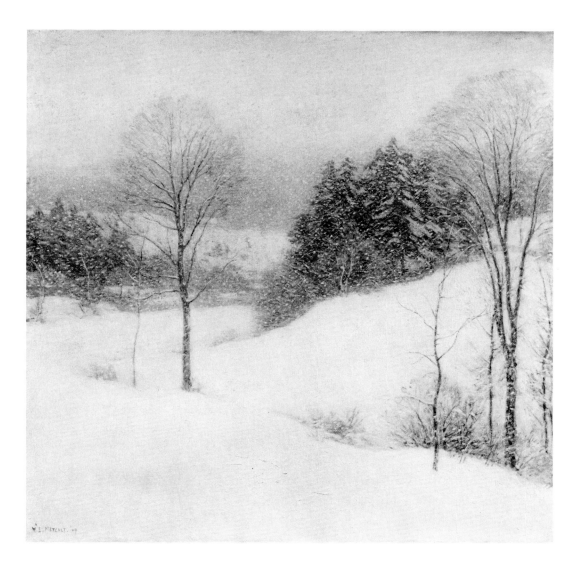

weather. Because Twachtman studied in France, exhibited his work with Monet's in New York in 1893, and was a close friend of Theodore Robinson, one of the first proponents of the French movement in America, he certainly felt these influences. Likewise, the restrained harmonies of Twachtman's color owe some debt to the American expatriate James McNeill Whistler. The necessarily reduced palette of snow scenes makes these subjects the perfect vehicle for such Whistlerian explorations of tone as *Round Hill Road* (cat. 14). At the turn of the century there appears, among many artists, a clear preference for nuance instead of color, for ambiguity instead of clarity, and for the landscape of mood.[32] These are best realized in the most suggestive times of day, dawn or dusk, and in the gauzy appearance of scenery in the mist or, as in Willard Leroy Metcalf's lovely *White Veil* (fig. 11), under falling snow. Such softly focused photographs of Edward Steichen as *Moonlight-Winter* (fig. 12) are another example of how this aesthetic current and the preference for winter subjects coincided in works of art.

Twachtman transformed all of these aspects of late nineteenth-century style into an

fig. 12. Edward Steichen, *Moonlight-Winter,* 1902. The Metropolitan Museum of Art, New York, Gift of Alfred Stieglitz, 1933

unusual personal language. There is a richness in his application of paint that goes beyond the monochromatic propensities of the tonalists, but also retains an extreme lightness of touch atypical of the impressionists. The challenges of painting the color white, exemplified not only in landscapes, but also in the many portraits by Twachtman's contemporaries that lavish attention on the light summer dresses worn by their sitters, was a test the artist eagerly embraced. The snow Twachtman painted is never a true, bright white. Thick, aggressively applied impasto is tempered by areas of the canvas' exposed ground, or gently tinted with faint grays, blues, or mauves. The veils of color in his work are formed with delicate networks of brushstrokes, some short and dry and often in unexpected colors like salmon or green, some small patches of wetter, thinly applied pigment with grays and purples predominating, but never from broadly applied glazes. Using this method Twachtman chose to depict not glistening banks of fresh snow in sunlight, but soft mounds enveloped in the damp, gray atmosphere so common to winter weather along the Connecticut shore.

Writing to Weir from his Greenwich home, Twachtman observed: "I feel more and more contented with the isolation of country life. To be isolated is a fine thing and we are nearer to nature.—I can see how necessary it is to live always in the country—at all seasons of the year."[33] To achieve the meditative quality that permeates his winter scenes it was essential for Twachtman to use as his subject a landscape unsullied by the

intrusions of human activity and modern life. In this quality Twachtman's work stands in contrast to the urban environment depicted in the sensitive evocations of conditions of time and weather of his friend Childe Hassam. One of the most ambitious of these, *Boston Common at Twilight* (fig. 13), shows pedestrians walking along the snow-covered park as the sun descends in the warm yellow-orange light glimpsed through the trees and buildings on the horizon. As beautiful and truthful as Hassam's observations are, because of both their urban subjects and their more analytical approach they are less conducive to reflection and sentiment than are Twachtman's winter images.

The term sentiment, as here applied, reflects a turn-of-the-century usage aptly defined by Wanda Corn:

> To the artists of mood, sentimentality was artificial and affected, appealing to such specific and identifiable emotions as patriotism, love, pity, or sorrow. "Sentiment," on the other hand, was more amorphous, akin to the profound depth of feeling which an intensely beautiful moment in nature might create in a person. To find "sentiment" in a work meant that the artist had convincingly reproduced not only what he saw in nature but his emotional response to it as well.[34]

Of all of Twachtman's landscapes it is the winter scenes that most successfully transmit this emotional response. It is as if the very stillness, emptiness, and silence of these dormant woods and fields, in the first instance, and the delicate, subdued artist's palette, in the second, act as a psychological and visual tabula rasa. The paintings become not only conveyors of, but facilitators of, sentiment. Neither obviously cheerless nor

blatantly cheerful, these quiet landscapes become objects of meditation, receptacles for thought.

After Twachtman's death, in the first few decades of the twentieth century there was an enormous proliferation of artists exploring the theme of the winter landscape.[35] Twachtman's admirer and student Ernest Lawson became well known for his energetically brushed views of snow and ice-clogged urban riverfronts. In the city itself George Bellows produced the most forceful and exciting snow scenes of any of the Ashcan painters. An entire school of late impressionist artists arose in Pennsylvania, one of whose major subjects was the snow-covered countryside. Among them painters such as Edward Willis Redfield (1869–1965) and Walter Elmer Schofield (1867–1944) made handsome images of glistening streams flowing through pristine, sunlit fields and groves. In New England their counterparts were Willard Leroy Metcalf and George Gardner Symons (1863–1930). The popularity of Walter Launt Palmer's snow scenes continued unabated.

Without exception these varied interpretations were more literal, more material, and more representative of objective reality than Twachtman's views. Many artists mimicked his compositions and his choice of subject. Others tried more original directions. None, however, approximated the ethereal vision of winter's beauty and repose that came and went with John Twachtman.

Notes

1. Twachtman to J. Alden Weir, Greenwich, Connecticut, 1891, in Dorothy Weir Young, *The Life & Letters of J. Alden Weir* (New Haven, 1960), 190.

2. Gerald Carr, *Frederic Edwin Church: The Icebergs* (Dallas Museum of Fine Arts, 1980).

3. See Martha Young Hutson, "Nineteenth Century American Winter Landscape Painting," and "The Rise of Winter Landscape Painting in America," introduction and chapter 4 respectively of *George Henry Durrie (1820–1863)* (Santa Barbara, 1977).

4. The similarity was noticed by several art historians. See Hutson 1977, introduction, note 5.

5. For examples see Wolfgang Stechow, "Winter," chapter 2 of *Dutch Landscape Painting of the Seventeenth Century* (London, 1968).

6. John Greenleaf Whittier, *Snow-Bound, A Winter Idyll* (Boston, 1868), 64.

7. Hutson 1977, 89.

8. Hutson 1977, 89.

9. Hutson 1977, 166.

10. Henry David Thoreau, "A Winter Walk," *Dial* 4 (October 1843), 225.

11. Among them are William Gibson, "Winter Walk," *Harper's Magazine* 72 (December 1885), 68–81, and John Albee, "My Farm in Winter," *New England Magazine* n.s. 21 (November 1899), 476–480.

12. Thomas W. Dewing et al., "John H. Twachtman: An Estimation," *North American Review* 176 (4 April 1903), 554–555.

13. Dewing 1903.

14. Among these studies by La Farge are: *Snow Field, Morning, Roxbury* (1864, Art Institute of Chicago); *Snow Storm* (1865, Mr. and Mrs. Glenn Verrill); *Pines in Snow* (1870s, Fraad Collection); and *Snow Weather. Sketch* (The Art Museum, Princeton University).

15. John Douglass Hale, *The Life and Creative Development of John H. Twachtman*, Ph.D. dissertation, Ohio State University, 1957 (Ann Arbor, 1957), microfilm, III. According to Hale, Twachtman wore "fur-lined woodsman's boots for standing in the snow."

16. Carolyn Mase, "John H. Twachtman," *The International Studio* 72 (January 1921), 72.

17. On the ice near Giverny Monet "warmed his hands with hot water bottles so that he could manipulate his brush." William C. Seitz, *Claude Monet* (New York, 1960), 76.

18. J. Alden Weir executed a series of snowscapes between 1894 and 1897, likely painted from "The Palace Car, a small house on runners equipped with an oil stove and having windows on all four side." Doreen Bolger Burke, *J. Alden Weir: An American Impressionist* (Newark, New Jersey, 1983), 219.

19. Henry T. Tuckerman, *Book of the Artists* (New York, 1967 reprint of 1870 edition), 546. See also the account of McEntee's painting *Winter in the Country* (1891) by David Steinberg in *American Paradise: The World of the Hudson River School* (The Metropolitan Museum of Art, New York, 1987), 282–283.

20. Frank Townsend Hutchens, "Winter in Water-Colors," *Art Amateur* 44 (March 1901), 99.

21. Marjorie R. Kaufman, ed., *The Poetical Works of James Russell Lowell* (Boston, 1978), 292.

22. Thoreau 1843, 214.

23. Thoreau 1843, 216.

24. Edwin S. Martin, "Winter in the Country," *Harper's Magazine* 107 (November 1903), 846.

25. For a history of Eickemeyer and his work see Mary Panzer, *In My Studio: Rudolf Eickemeyer, Jr. and the Art of the Camera 1885–1930* (Yonkers, N.Y., 1986).

26. *Winter*, introduction by Sadakichi Hartmann (New York, 1903).

27. John C. Van Dyke, *Nature for Its Own Sake* (New York, 1898), 170.

28. Van Dyke 1898, 110.

29. Maybelle Mann, *Walter Launt Palmer: Poetic Reality* (Exton, Pa., 1984), 53.

30. Mann 1984, 41.

31. Clarence Cook, "Paintings in Oil and Pastels by J.H. Twachtman," *Studio* n.s. 6 (28 March 1891), 162.

32. This movement is discussed in Wanda Corn, *The Color of Mood: American Tonalism 1880–1910* (San Francisco, 1972).

33. Young 1960, 189–190.

34. Corn 1960, 2.

35. For some examples, see Eliot Clark, "American Painters of Winter Landscape," *Scribner's Magazine* (December 1922), 763–768.

COLORPLATES

cat. 2. John Twachtman, *Icebound* (detail), 1889–1900.
The Art Institute of Chicago, Friends of American Art
Collection

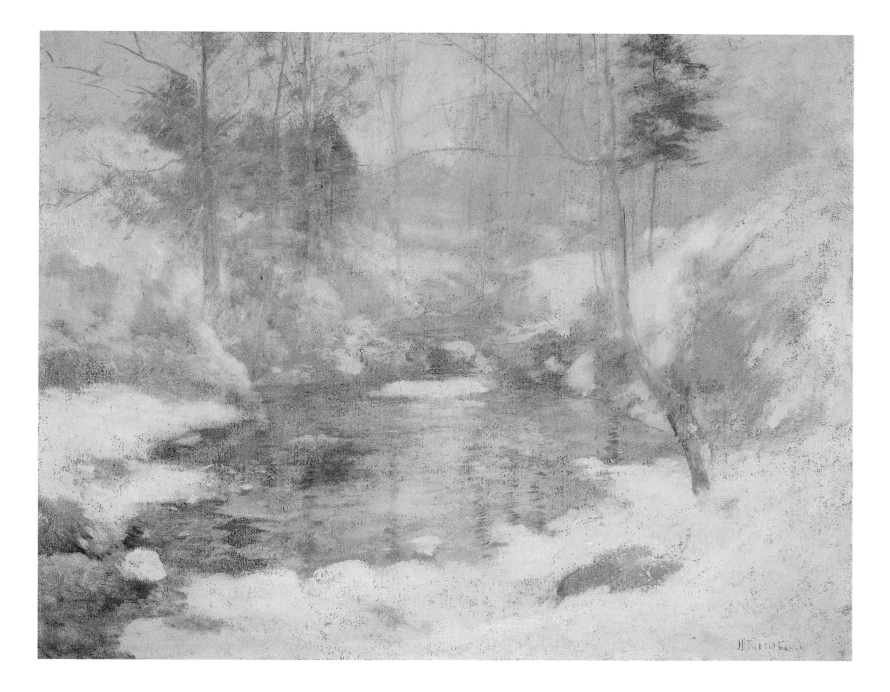

I

Winter Harmony

c. 1890/1900

25³/₄ x 32 (65.3 x 81.2)

National Gallery of Art, Washington,

Gift of the Avalon Foundation

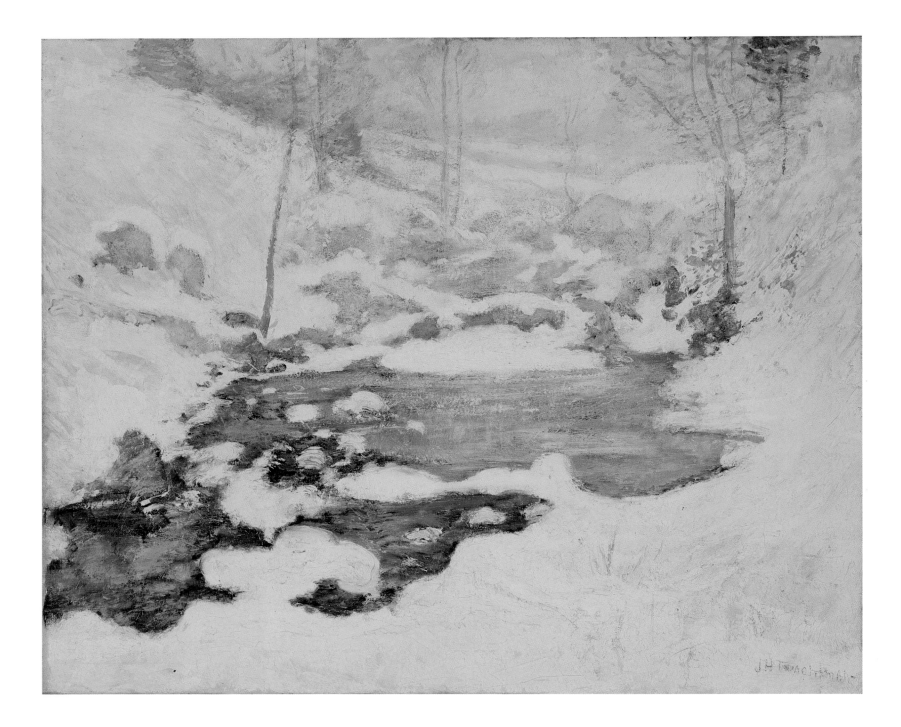

2

Icebound

1889–1900

25¼ x 30⅛ (64.2 x 76.9)

The Art Institute of Chicago,
Friends of American Art Collection

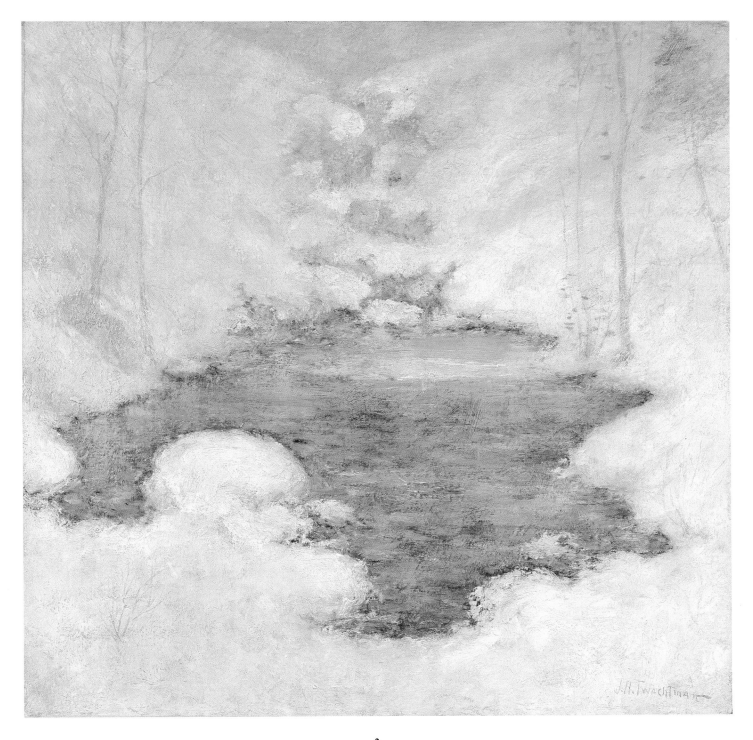

3
Winter Silence
c. 1890–1900
23 x 22½ (58.4 x 57.2)
Mead Art Museum, Amherst College,
Gift of Clay Bartlett

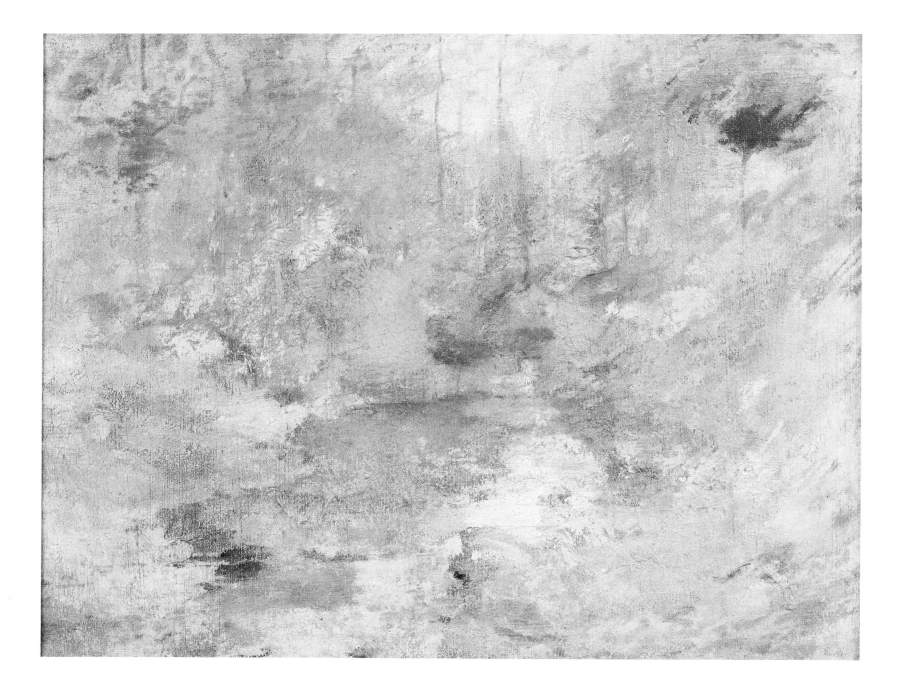

4
Hemlock Pool—Autumn
c. 1894
15½ x 19½ (39.4 x 49.6)
Private collection, Philadelphia,
Courtesy of Graham Gallery

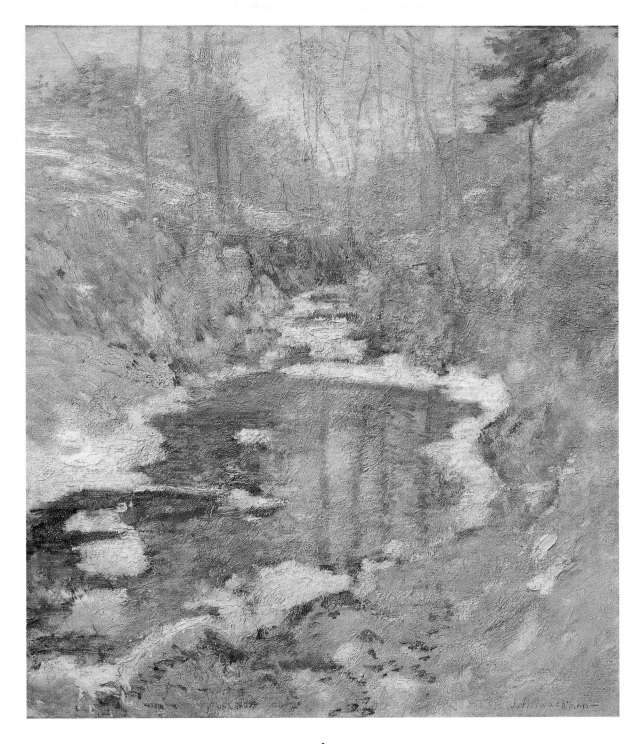

5
Hemlock Pool
c. 1900
30 x 25 (76.2 x 63.5)
The Addison Gallery of American Art, Phillips Academy, Andover, Massachusetts
(SHOWN IN WASHINGTON ONLY)

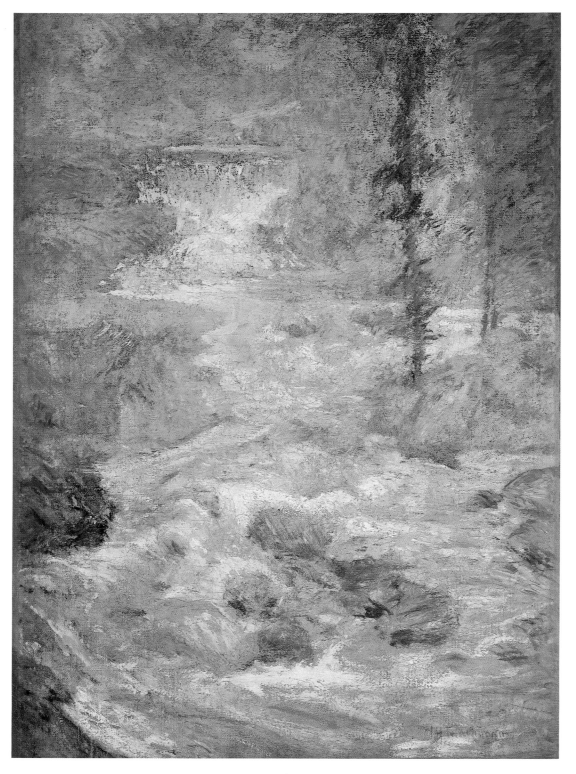

6
The Rainbow's Source
c. 1890–1900
24½ x 34⅛ (62.2 x 86.7)
The Saint Louis Art Museum, Purchase

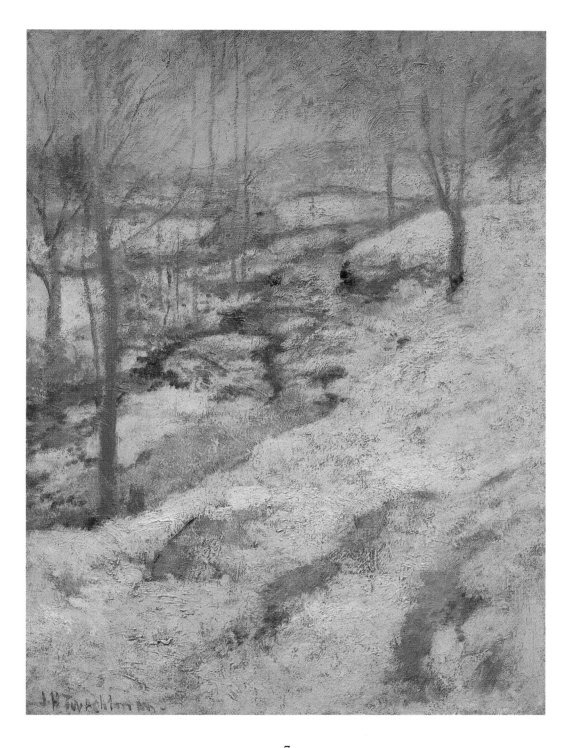

7

Frozen Brook

c. 1893

30 x 22 (76.2 x 55.9)

Mr. and Mrs. Ralph Spencer

(SHOWN IN WASHINGTON ONLY)

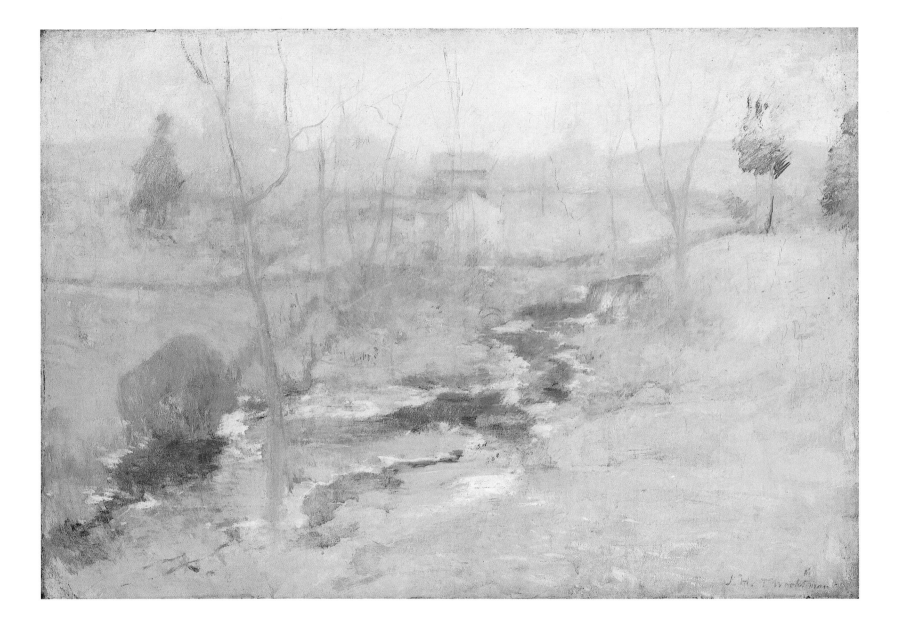

8
End of Winter
after 1889
22 x 30⅛ (55.9 x 76.5)
National Museum of American Art, Smithsonian Institution, Washington,
Gift of William T. Evans

9
The Snow Bound Stream
c. 1890–1900
30 x 30 (76.2 x 76.2)
Property of the David Warner Foundation, Tuscaloosa, Alabama

10
The Brook, Greenwich, Connecticut
c. 1890–1900
34⁷/₈ x 25¹/₈ (88.6 x 63.9)
National Museum of American Art, Smithsonian Institution, Washington,
Gift of John Gellatly

II

February

c. 1890–1900

36¹/₄ x 48 (92.1 x 121.9)

Museum of Fine Arts, Boston,

Charles Henry Hayden Fund

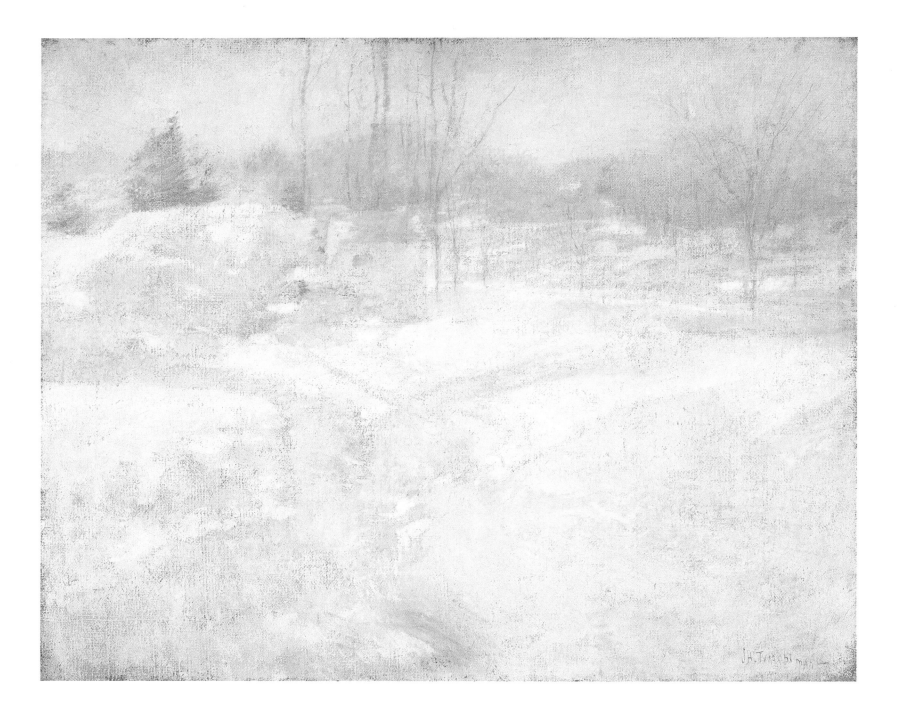

12
Winter
c. 1890
21⁵/₈ x 26¹/₈ (55 x 66.4)
The Phillips Collection, Washington

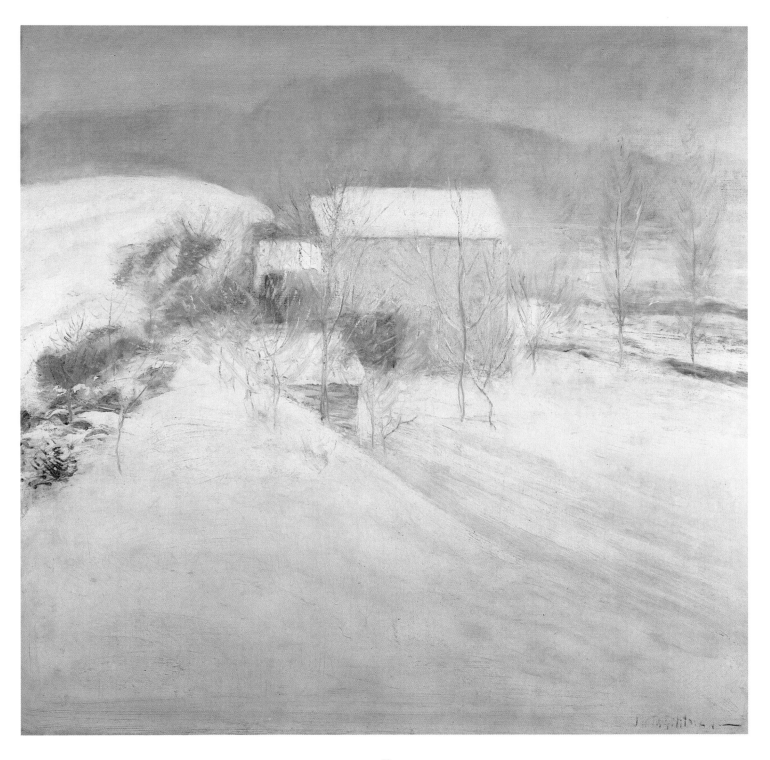

13
Snow
c. 1895–1896
30 x 30 (76.2 x 76.2)
Mr. and Mrs. Meyer P. Potamkin

14
Round Hill Road
c. 1890–1900
30¼ x 30 (76.5 x 76.2)
National Museum of American Art, Smithsonian Institution, Washington,
Gift of William T. Evans

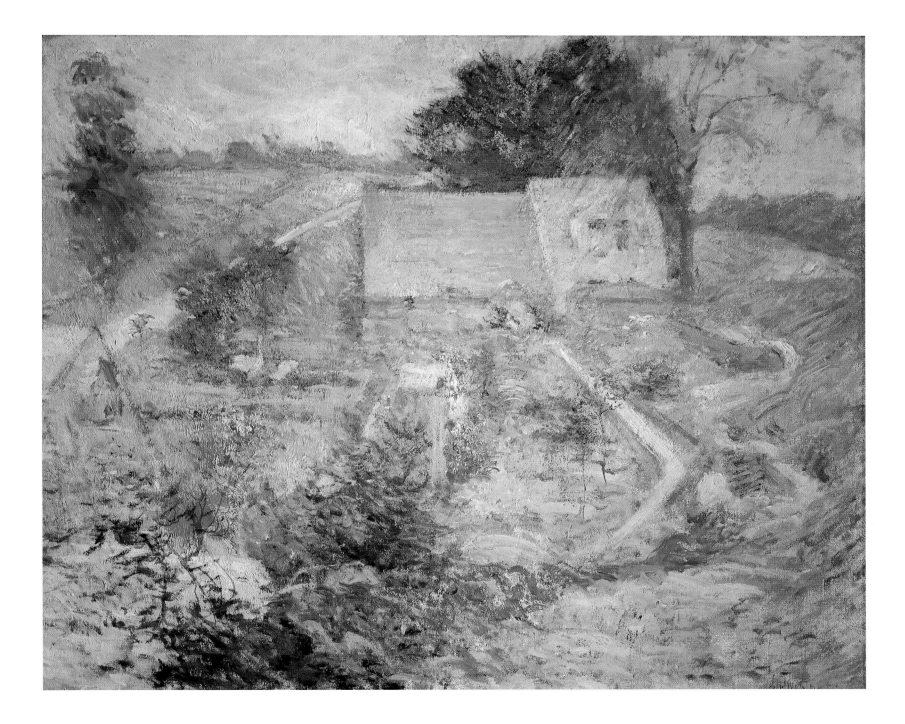

15
From the Upper Terrace
c. 1890–1900
25 x 30 (63.5 x 76.2)
File Collection,
Courtesy R. H. Love Galleries, Inc., Chicago

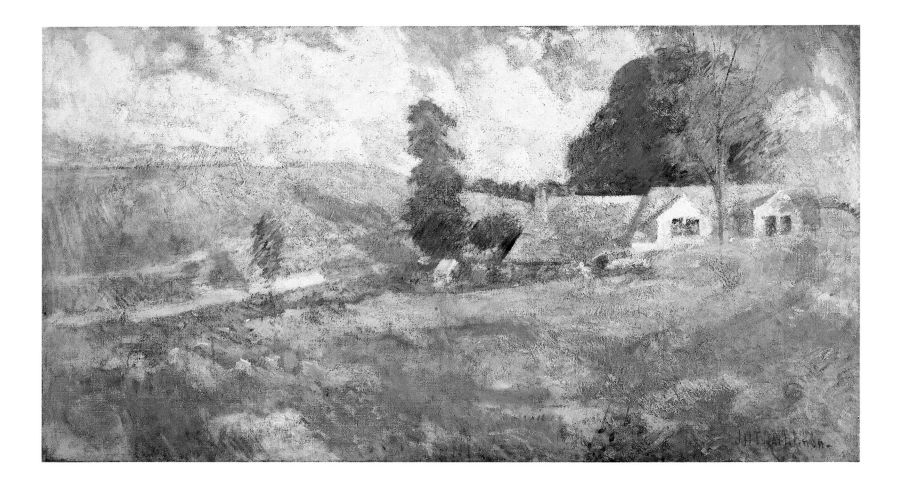

16
Summer
late 1890s
30 x 53 (76.2 x 134.6)
The Phillips Collection, Washington

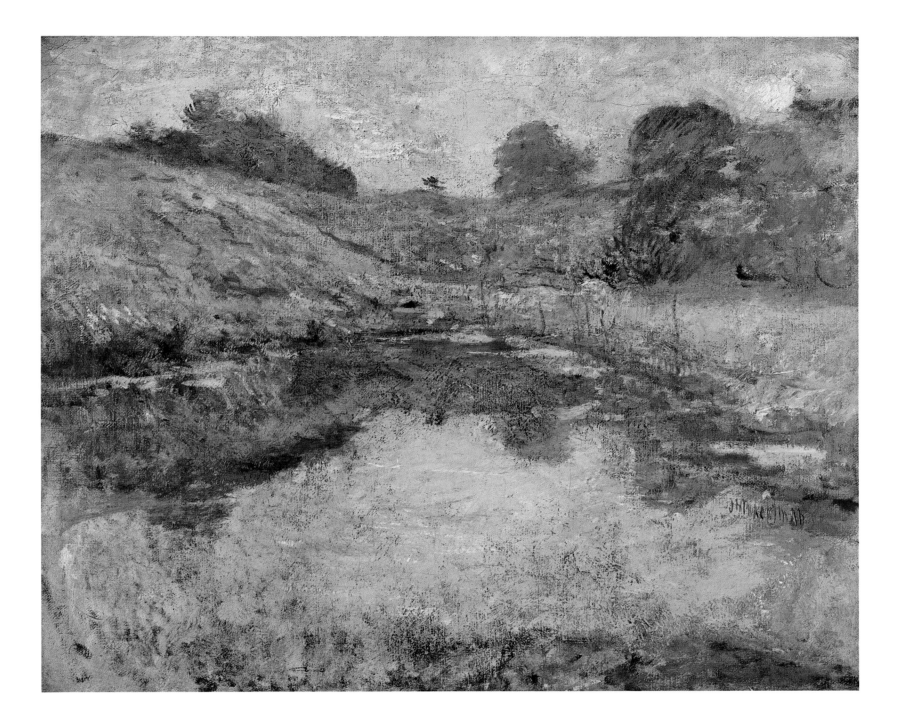

17
Spring Morning
c. 1890–1900
25 x 30 (63.5 x 76.2)
The Carnegie Museum of Art, Pittsburgh, Purchase, 1913

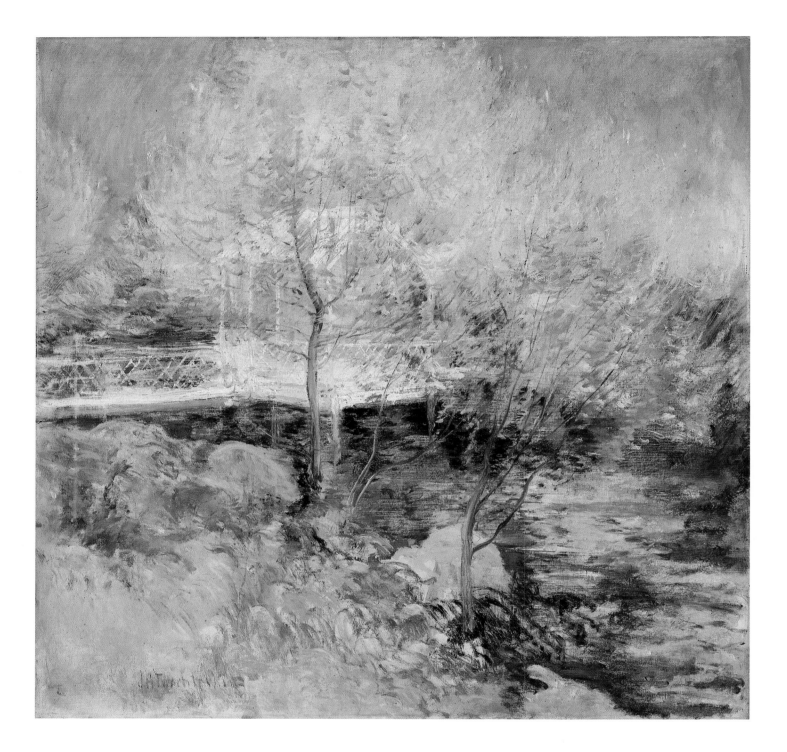

18
The White Bridge
1889–1900
30 x 30¼ (76.2 x 76.8)
The Art Institute of Chicago,
Mr. and Mrs. Martin A. Ryerson Collection

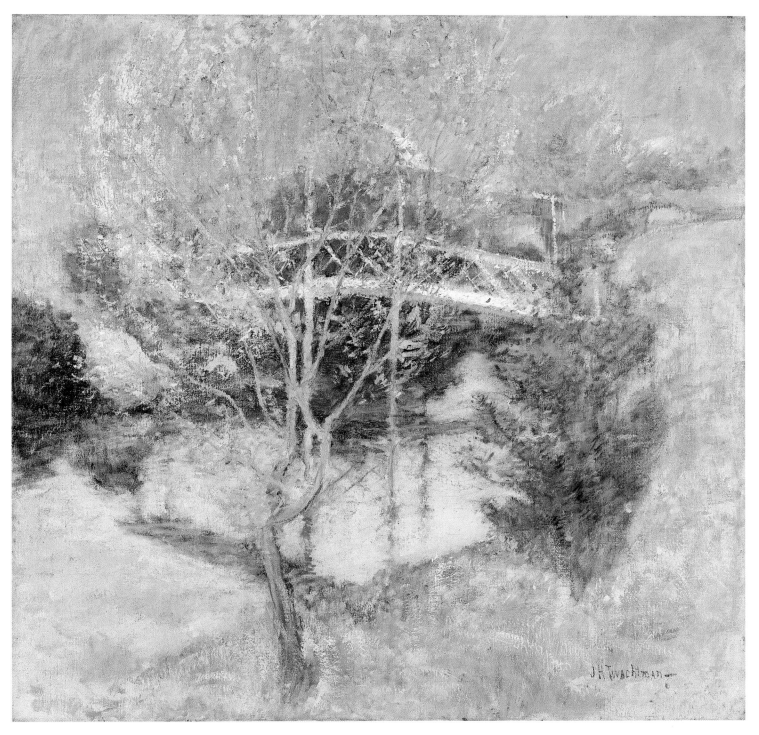

19
The White Bridge
after 1895
30¼ x 30¼ (76.8 x 76.8)
The Minneapolis Institute of Arts,
The Martin B. Koon Memorial Collection

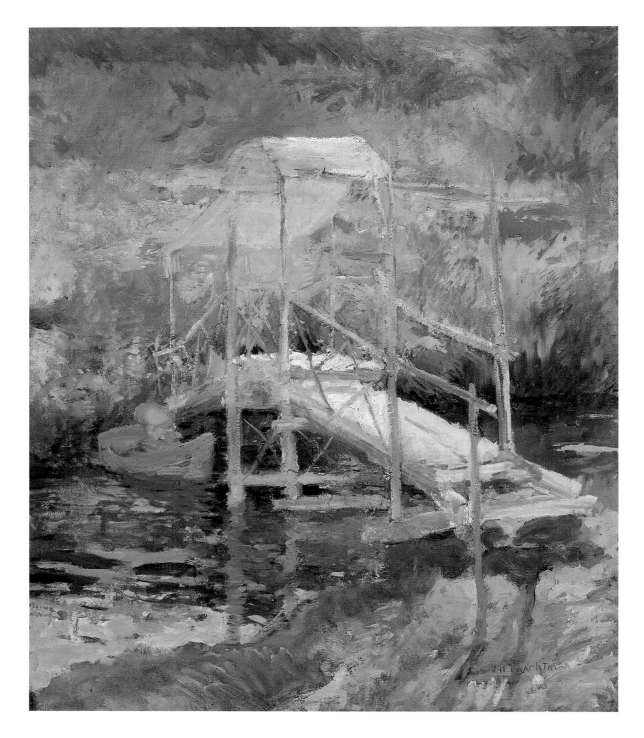

20

The White Bridge

c. 1900

30¼ x 25⅛ (76.8 x 64.1)

Memorial Art Gallery of the University of Rochester,
Gift of Emily Sibley Watson

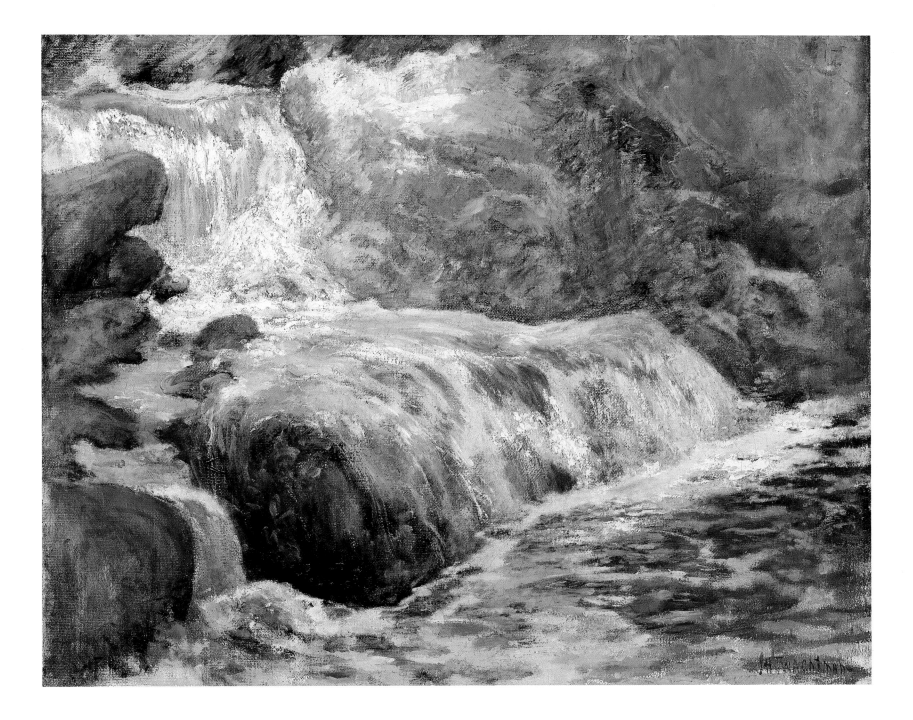

21
Waterfall, Blue Brook
c. 1899
25^1/$_8$ x 30^1/$_{16}$ (63.8 x 76.3)
Cincinnati Art Museum, Annual Membership Fund

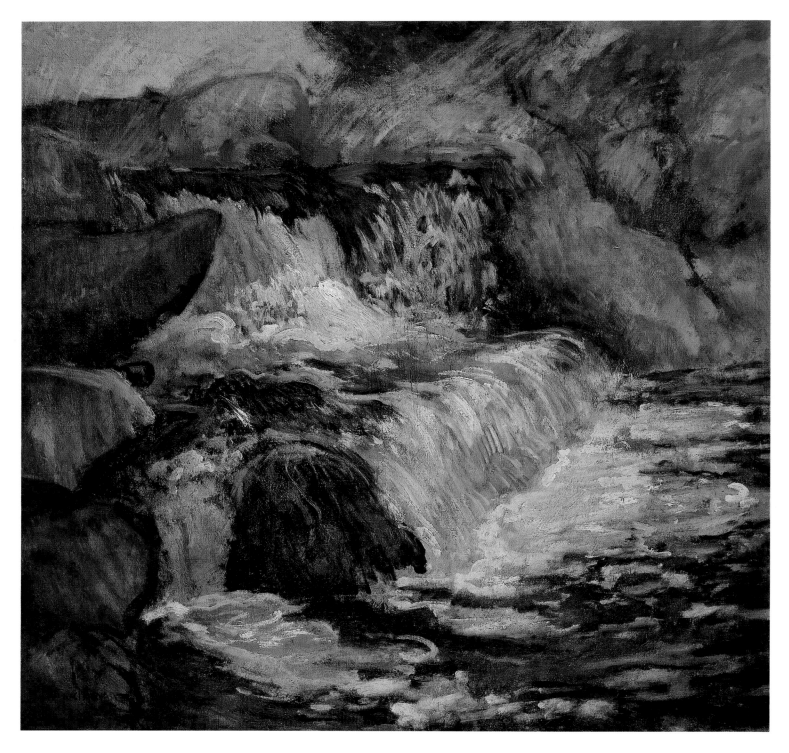

22
The Cascade
late 1890s
30 x 30 (76.2 x 76.2)
Collection IBM Corporation, Armonk, New York

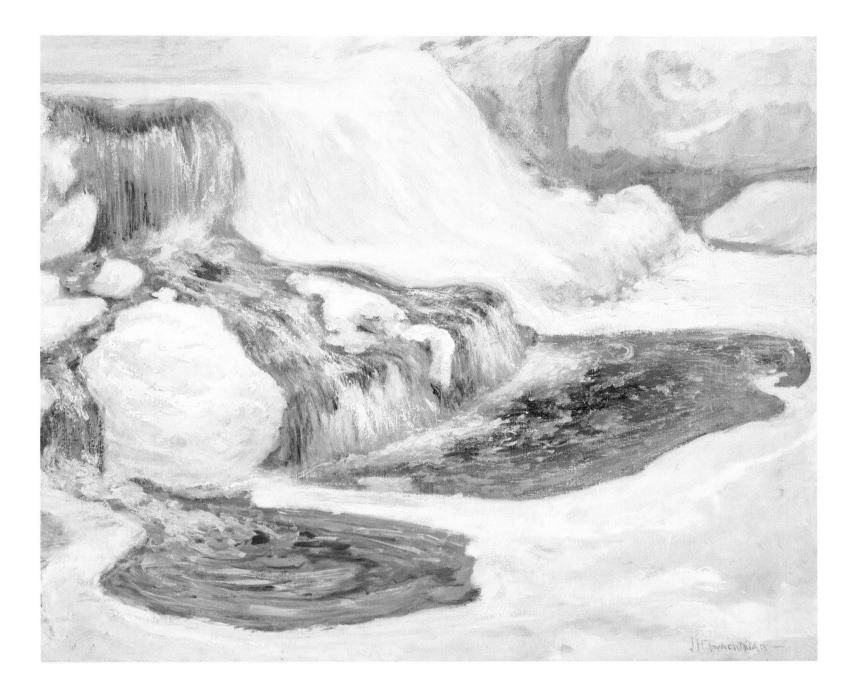

23
Falls in January
c. 1895
25¹/8 x 30 (63.8 x 76.2)
Wichita Art Museum, the Roland P. Murdock Collection

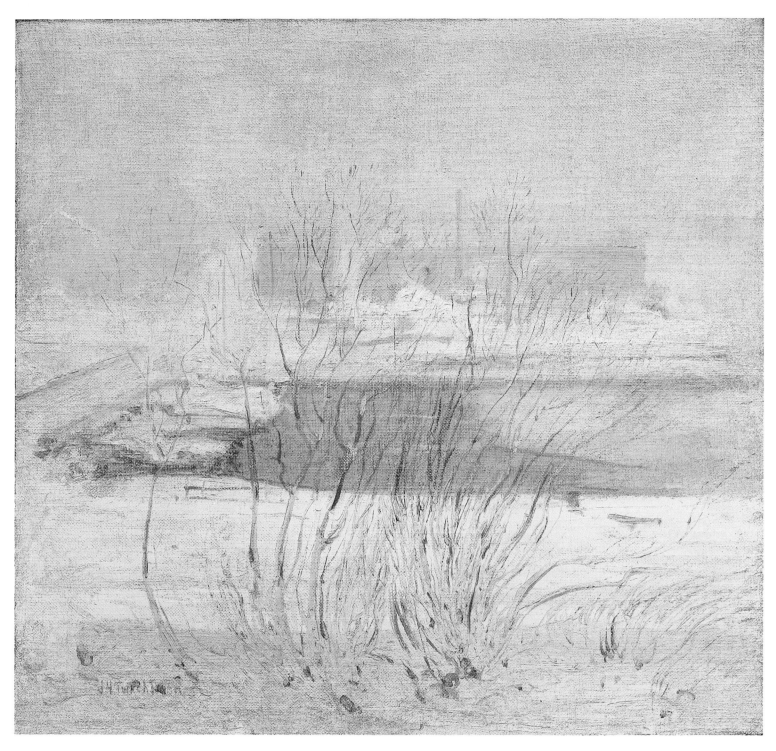

24
Bridge in Winter
C. 1901
30⅛ x 30⅛ (76.5 x 76.5)
Mr. and Mrs. Hugh Halff, Jr.

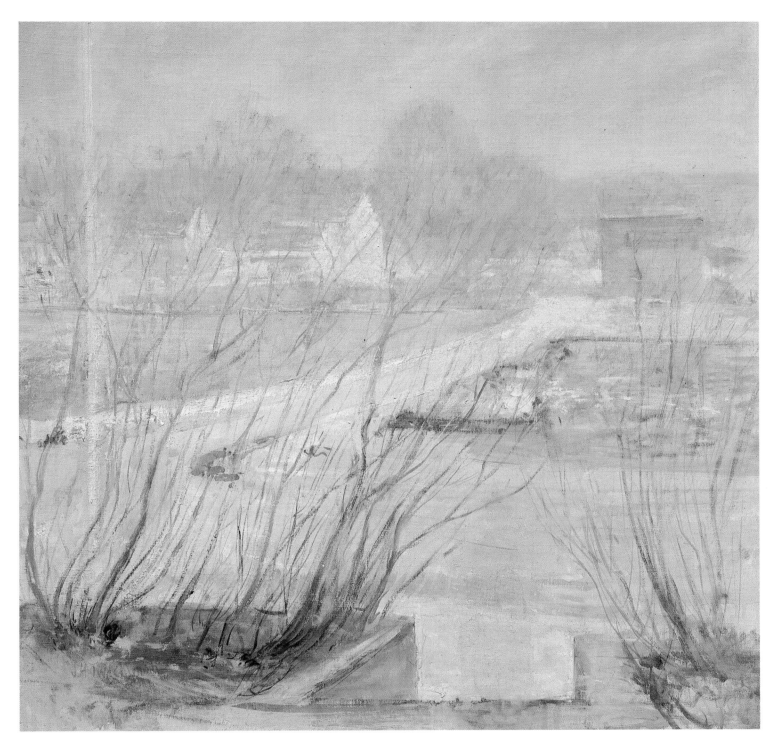

25
From the Holley House
C. 1901
30 x 30 (76.2 x 76.2)
Mr. and Mrs. Hugh Halff, Jr.

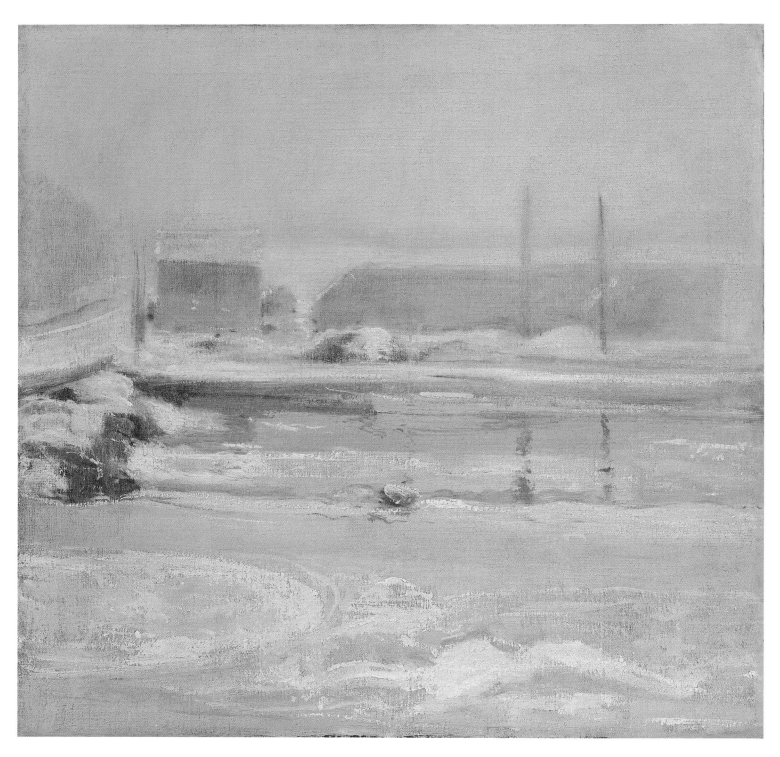

26
View from the Holley House, Winter
c. 1901
25¹/₈ x 25¹/₈ (63.8 x 63.8)
Spanierman Gallery, New York

SELECT BIBLIOGRAPHY

Hale, John Douglass, Richard J. Boyle, William H. Gerdts, and Lisa N. Peters. *In the Sunlight: The Floral and Figurative Art of J.H. Twachtman*. Exh. cat. Ira Spanierman Gallery. New York, 1989.

Hale, John Douglass, Richard J. Boyle, and William H. Gerdts. *Twachtman in Gloucester: His Last Years, 1900–1902*. Exh. cat. Ira Spanierman Gallery. New York, 1987.

Gerdts, William H. *American Impressionism*. New York, 1984.

Larkin, Susan G. ''The Cos Cob Clapboard School.'' *Connecticut and American Impressionism*. Exh. cat. The University of Connecticut. Storrs, 1980.

Boyle, Richard J. *John Twachtman*. New York, 1979.

John Henry Twachtman. Exh. cat. Cincinnati Museum of Art, 1966.

Hale, John Douglass. *The Life and Creative Development of John H. Twachtman*. 2 vols. Ph.D. diss. Ohio State University, 1957. Ann Arbor, 1957, microfilm.

Tucker, Allen. *John H. Twachtman*. New York, 1931.

Clark, Eliot. *John Twachtman*. New York, 1924.